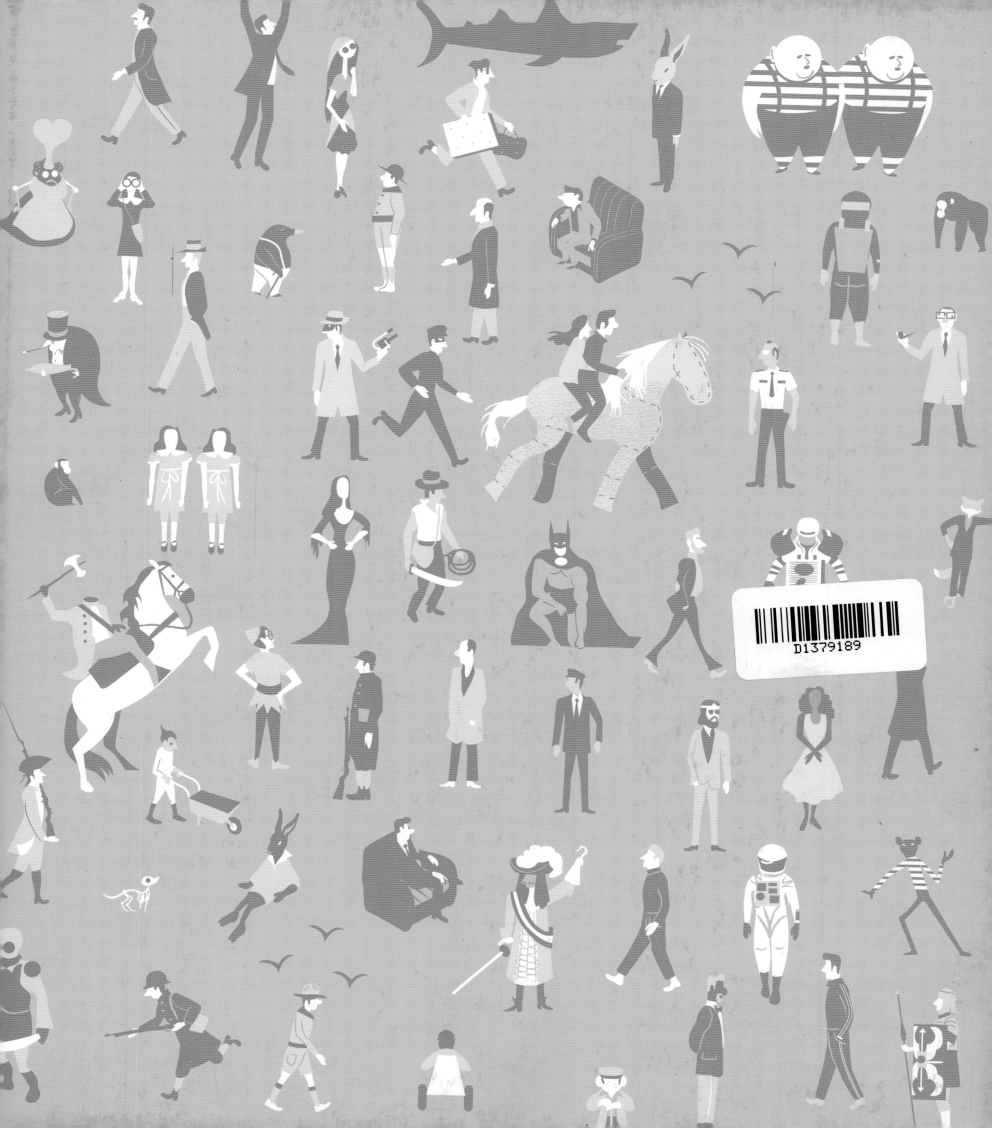

Alexandre Clérisse is a graduate from the EESI school of visual arts in Angoulême, France, a city where he still lives today. He is the illustrator of several comic books including *Jazz Club* and *Trompe la mort* (Daredevil). His collaborations with author Thierry Smolderen include *L'Été Diabolik* (Diabolik Summer) and *Souvenir de l'empire de l'atome* (Memories of the Atomic Empire), which received various awards including Best Science-Fiction Comic Book at the Nantes Utopiales festival, the Imaginaire award at the Étonnants Voyageurs festival in Saint-Malo, and the Tour d'ivoire award. When Alexandre hides, playing hide-and-seek with his son, his best hiding place is standing behind the curtains. Even though his feet stick out, it always works.

ALEXANDRE CLÉRISSE

NOW PLAYING

A SEEK-AND-FIND BOOK FOR FILM BUFFS

CHRONICLE BOOKS

SAN FRANCISCO

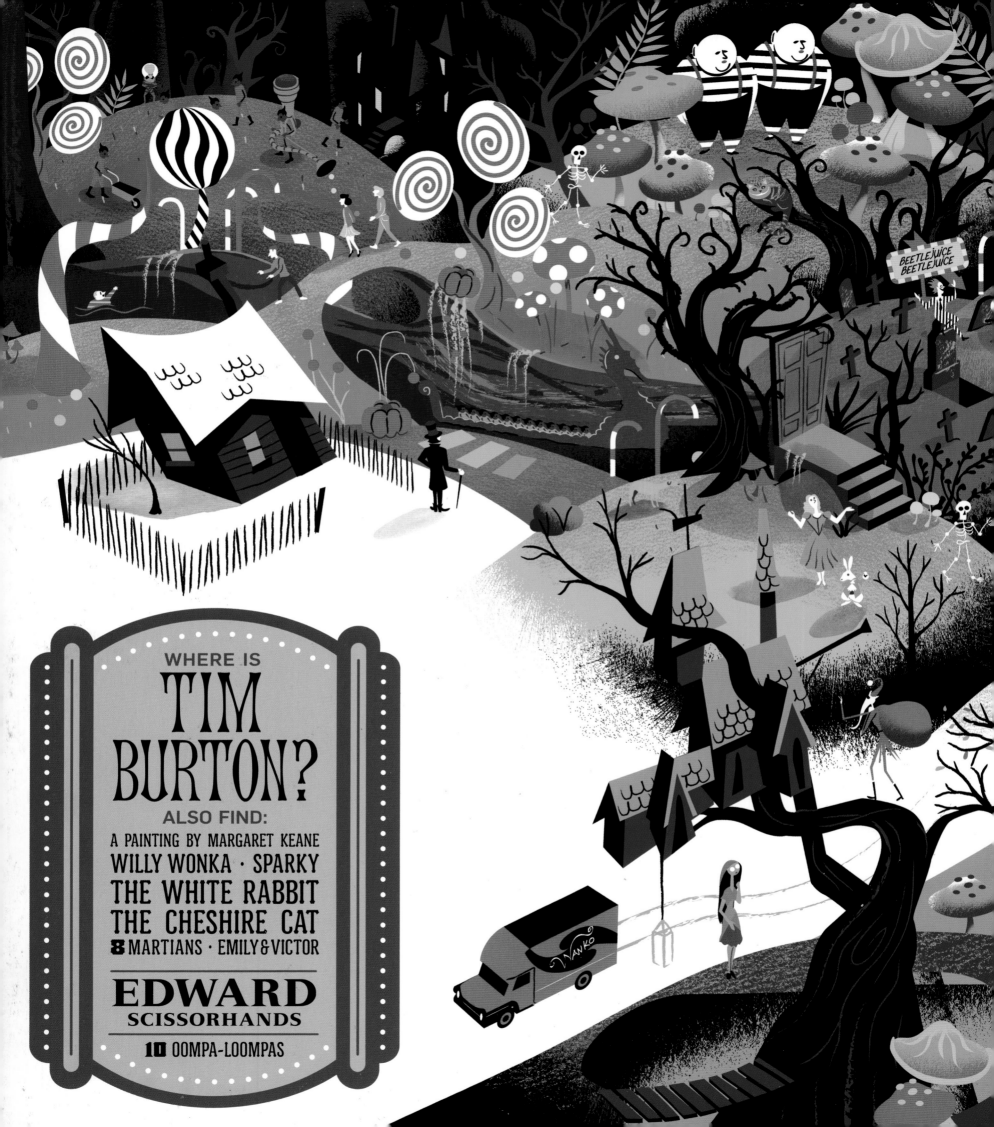

WHERE IS
TIM
BURTON?
ALSO FIND:
A PAINTING BY MARGARET KEANE
WILLY WONKA · SPARKY
THE WHITE RABBIT
THE CHESHIRE CAT
8 MARTIANS · EMILY & VICTOR

EDWARD
SCISSORHANDS
10 OOMPA-LOOMPAS

BEETLEJUICE
BEETLEJUICE

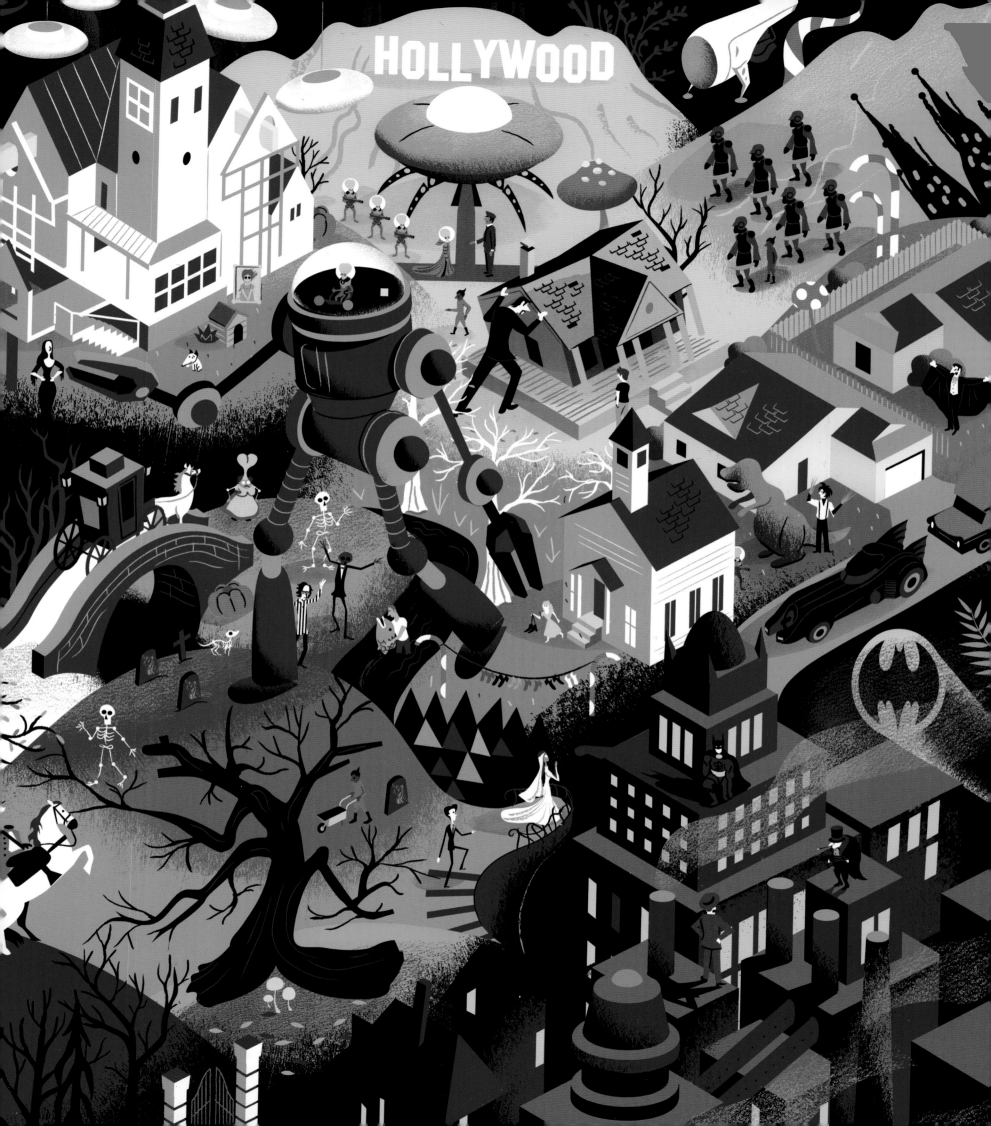

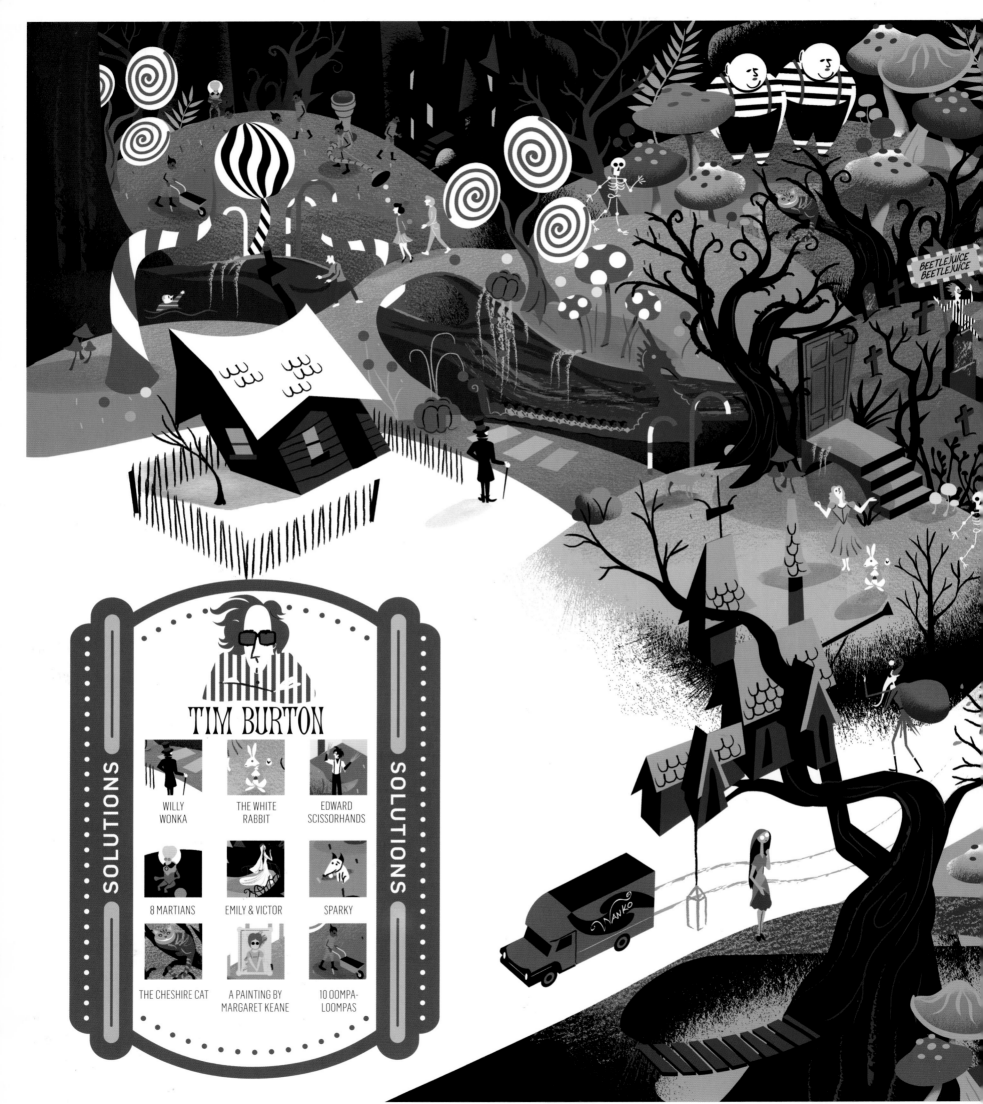

BEETLEJUICE BEETLEJUICE

TIM BURTON

SOLUTIONS

SOLUTIONS

WILLY WONKA

THE WHITE RABBIT

EDWARD SCISSORHANDS

8 MARTIANS

EMILY & VICTOR

SPARKY

THE CHESHIRE CAT

A PAINTING BY MARGARET KEANE

10 OOMPA-LOOMPAS

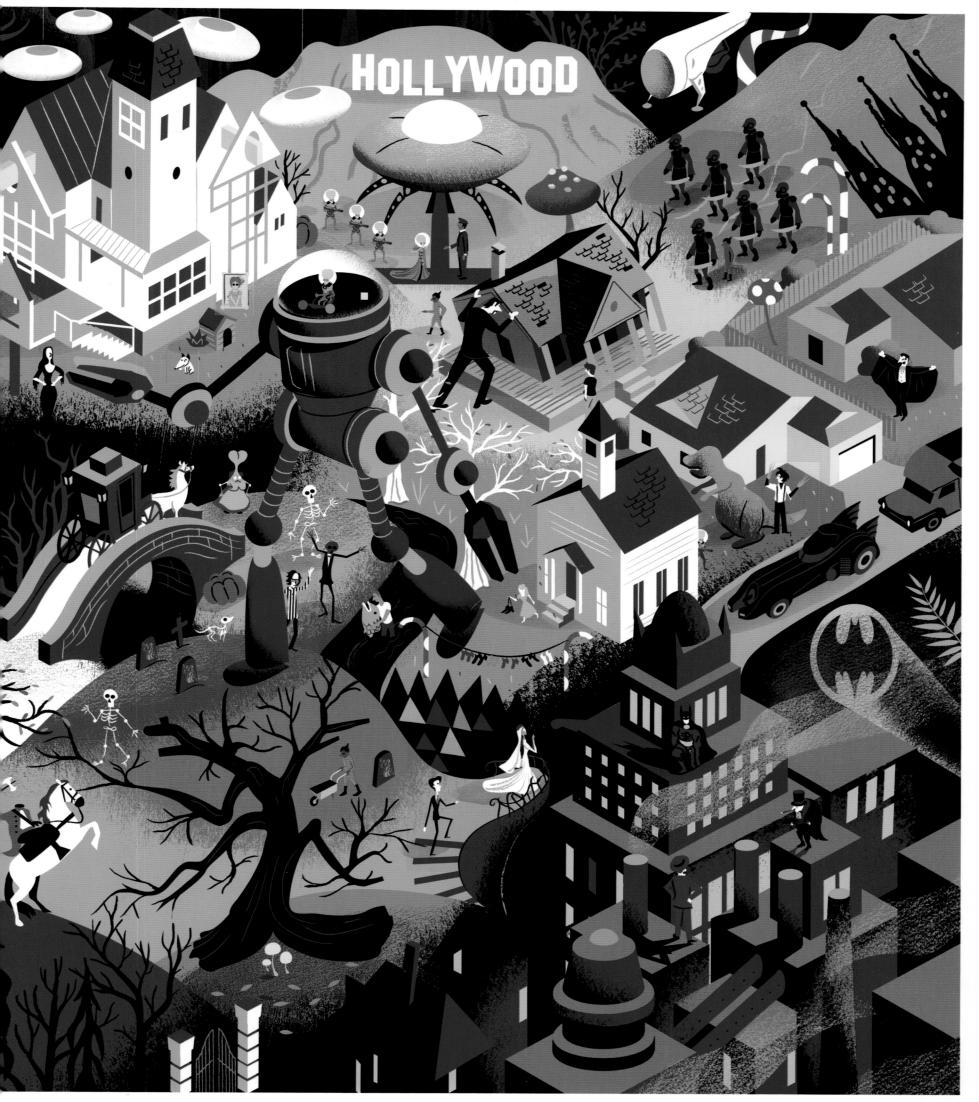

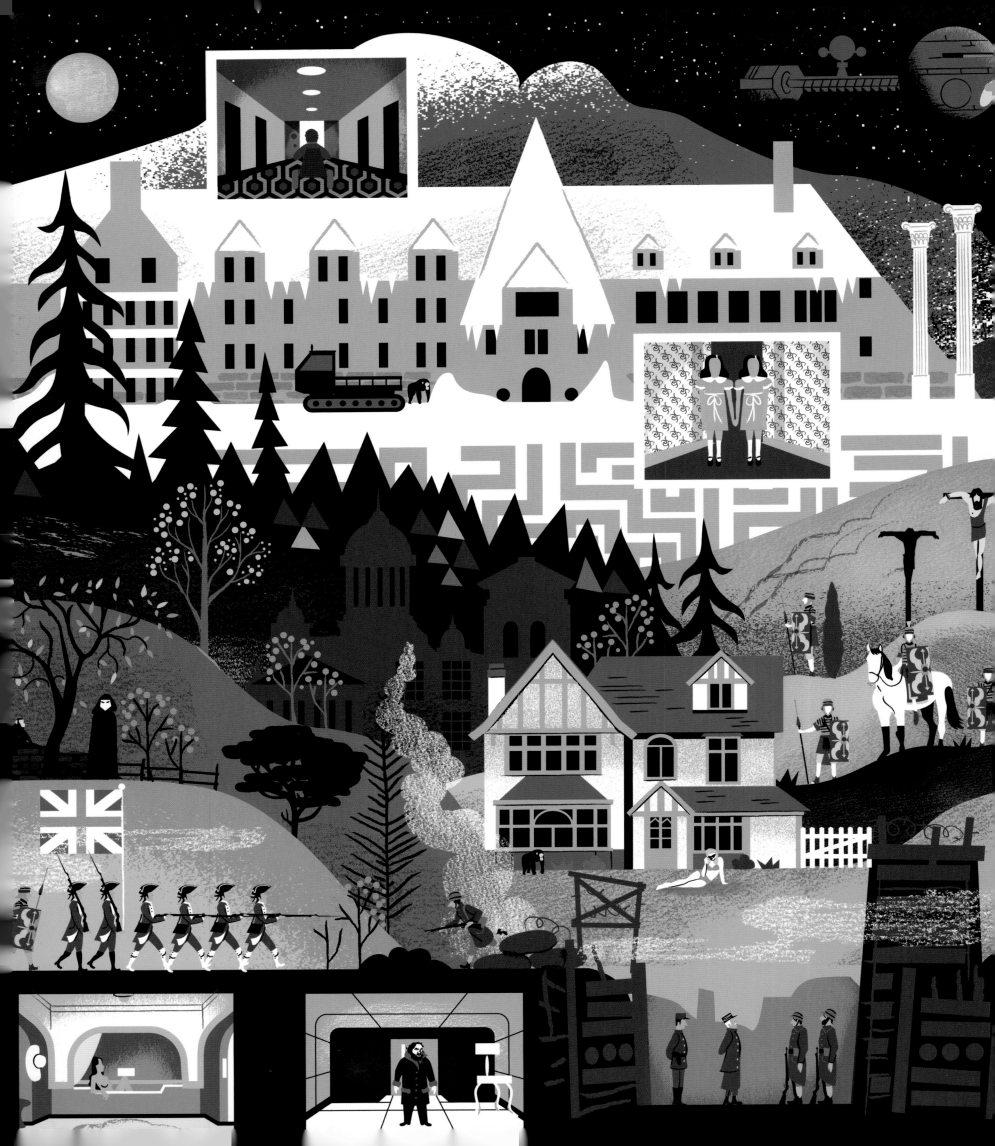

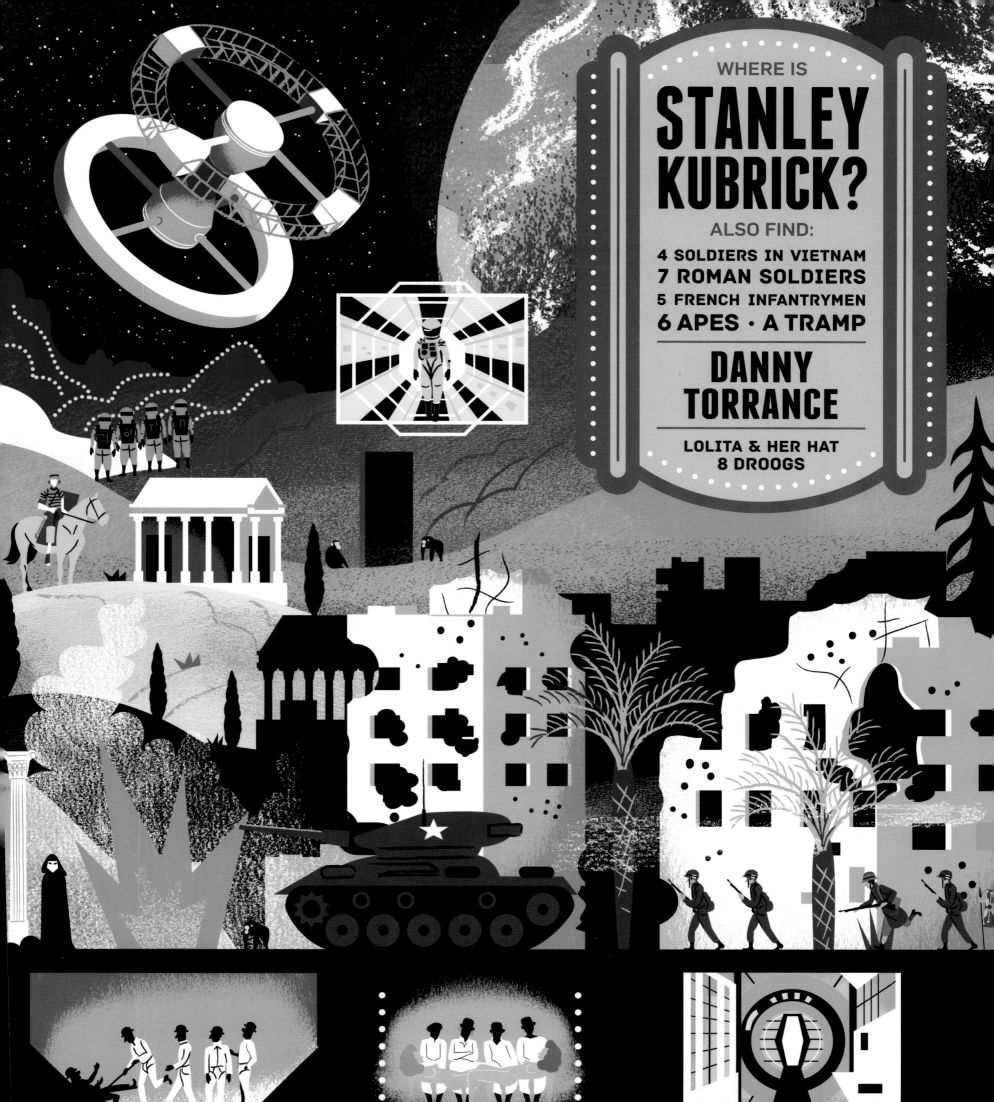

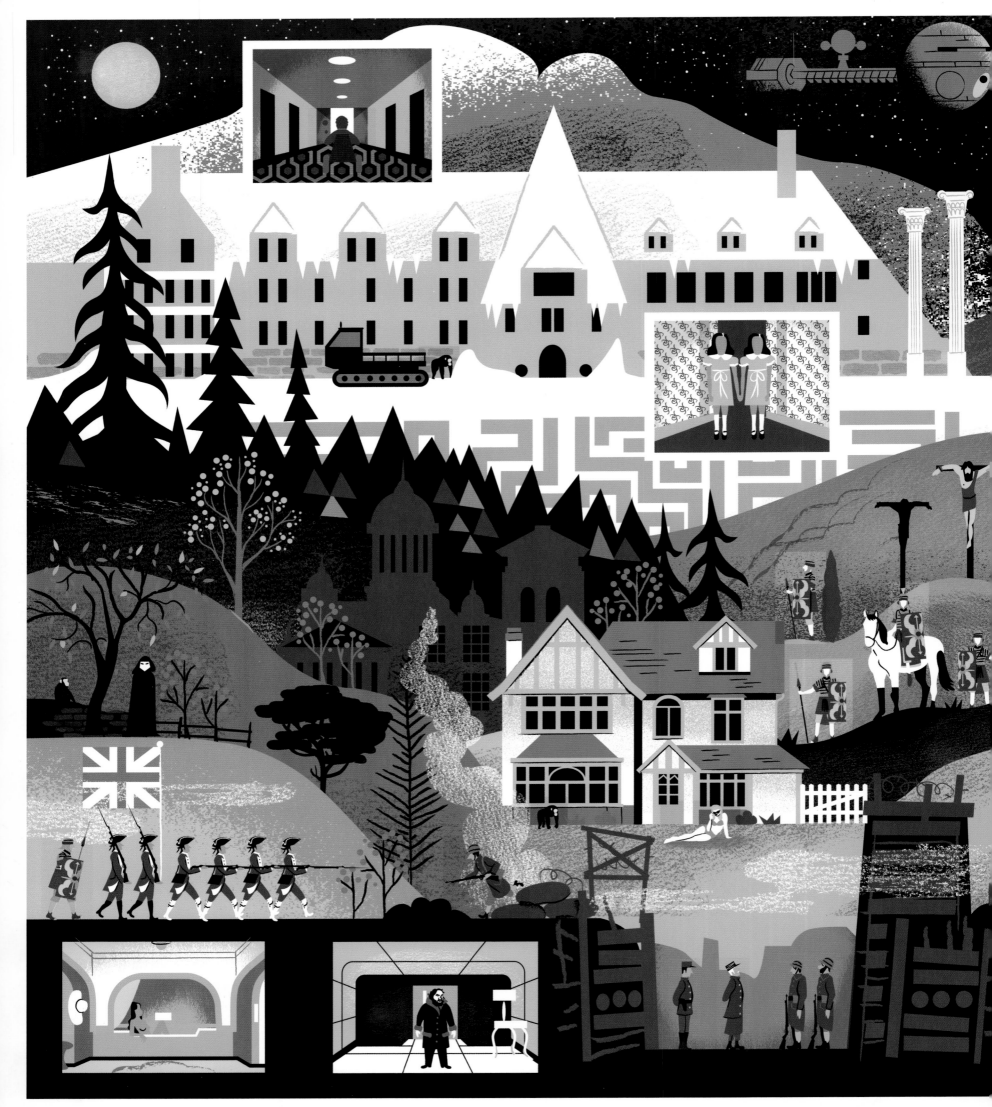

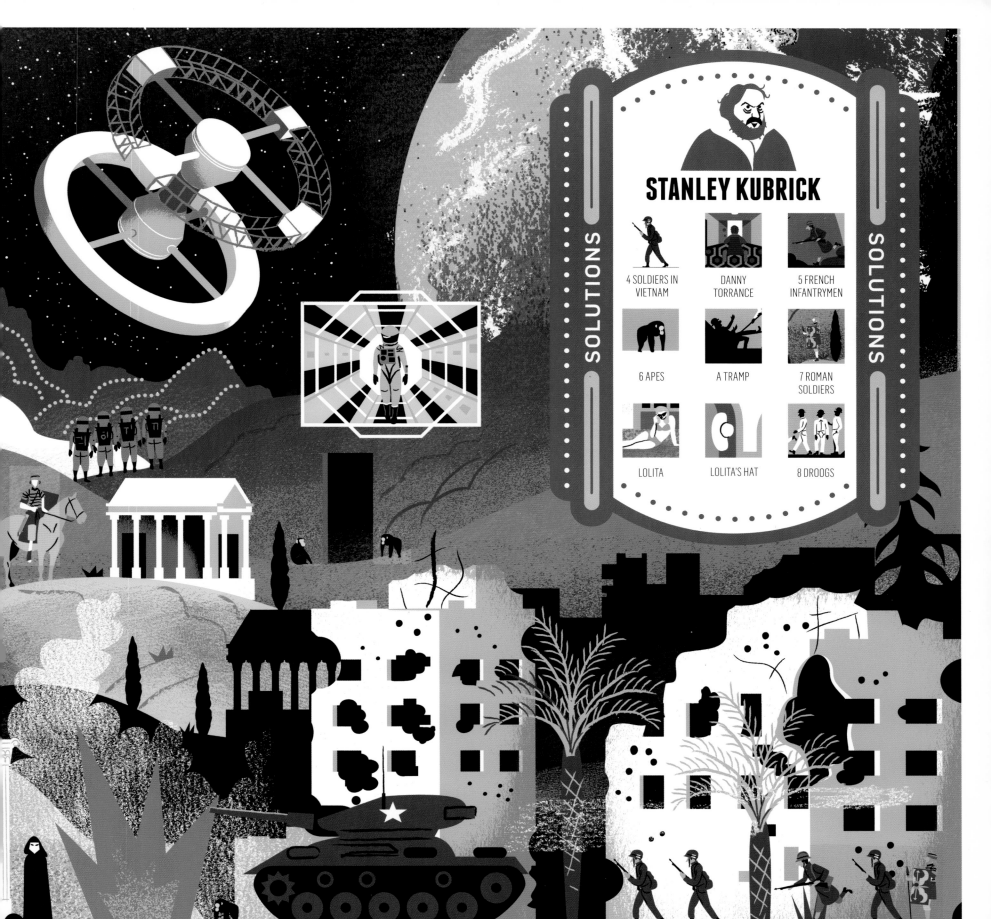

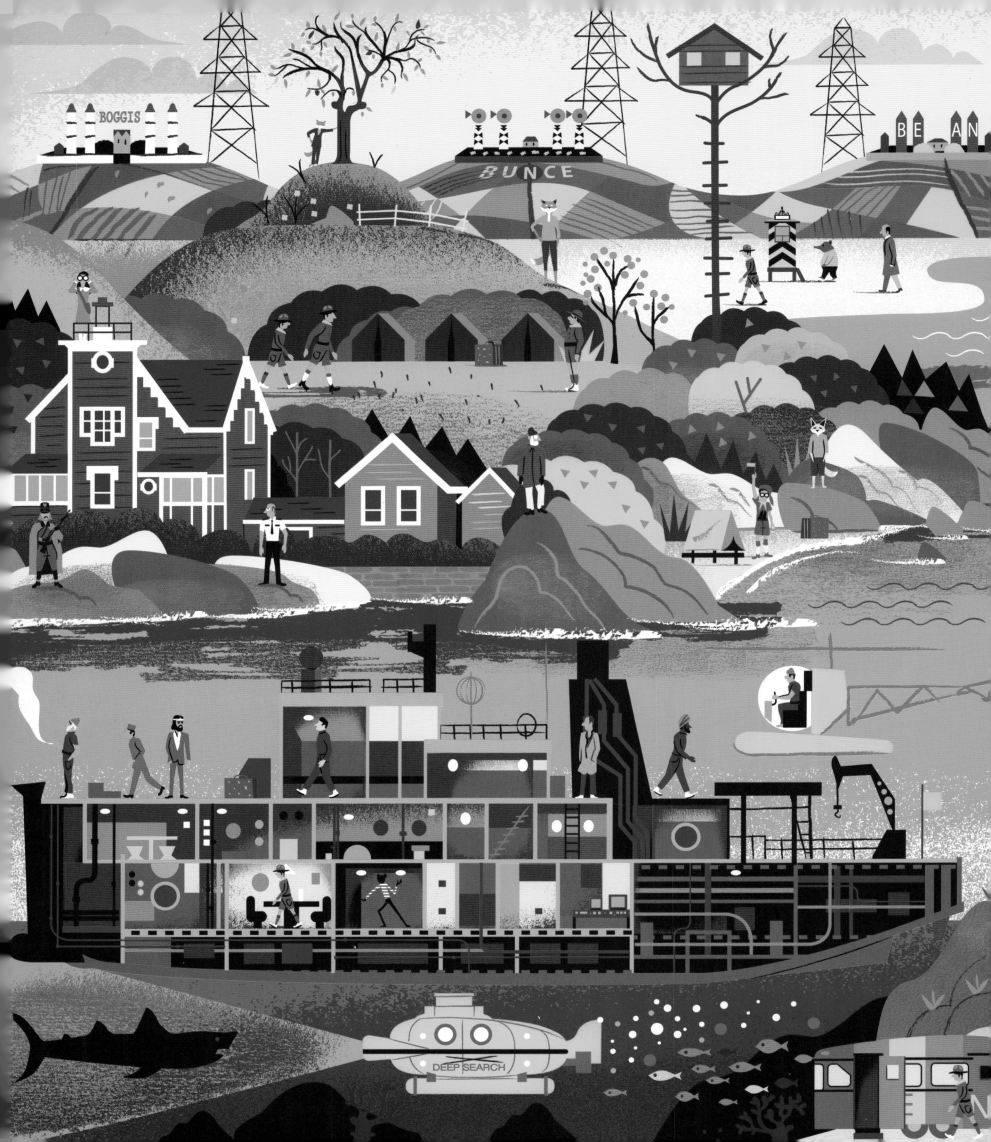

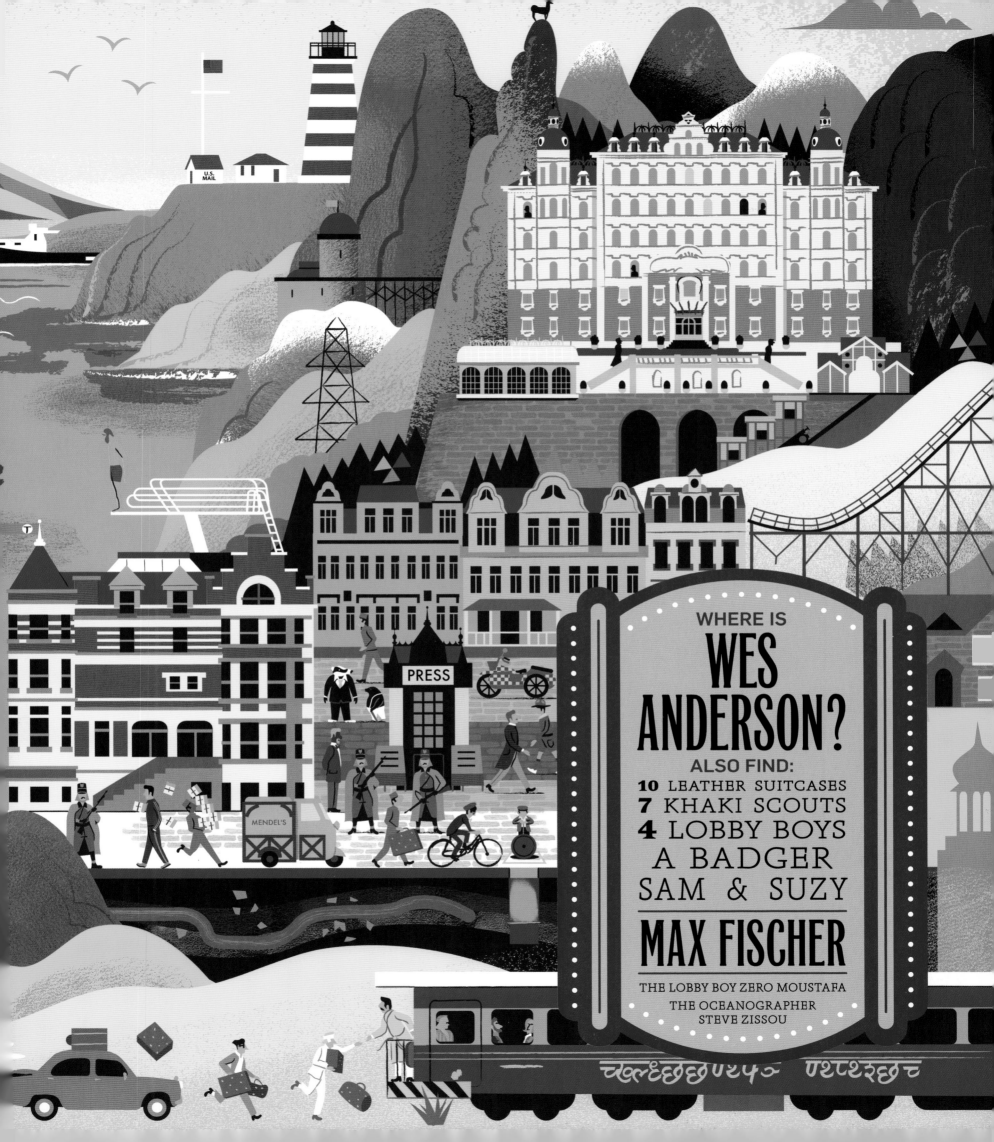

WHERE IS

WES ANDERSON?

ALSO FIND:

10 LEATHER SUITCASES

7 KHAKI SCOUTS

4 LOBBY BOYS

A BADGER

SAM & SUZY

MAX FISCHER

THE LOBBY BOY ZERO MOUSTAFA

THE OCEANOGRAPHER
STEVE ZISSOU

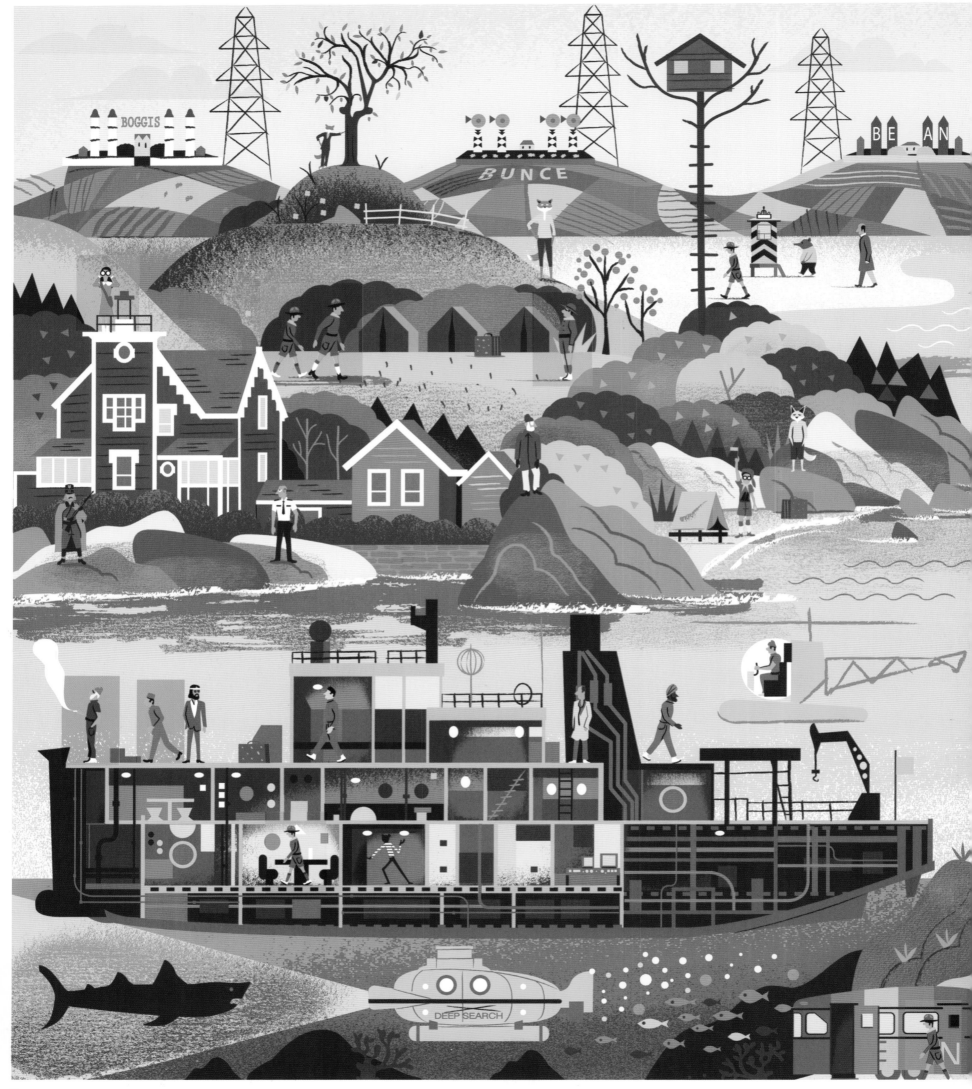

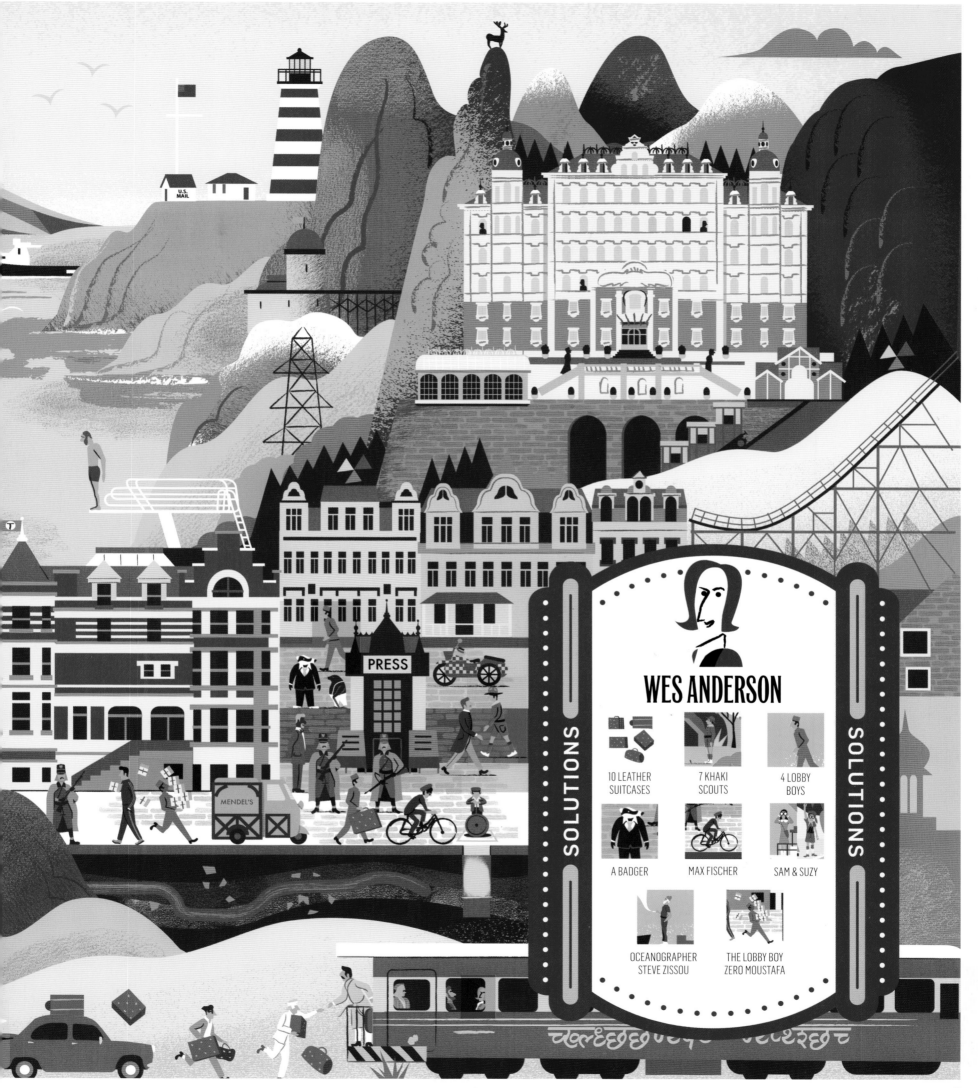

U.S. MAIL

PRESS

MENDEL'S

WES ANDERSON

SOLUTIONS

10 LEATHER SUITCASES

7 KHAKI SCOUTS

4 LOBBY BOYS

A BADGER

MAX FISCHER

SAM & SUZY

OCEANOGRAPHER STEVE ZISSOU

THE LOBBY BOY ZERO MOUSTAFA

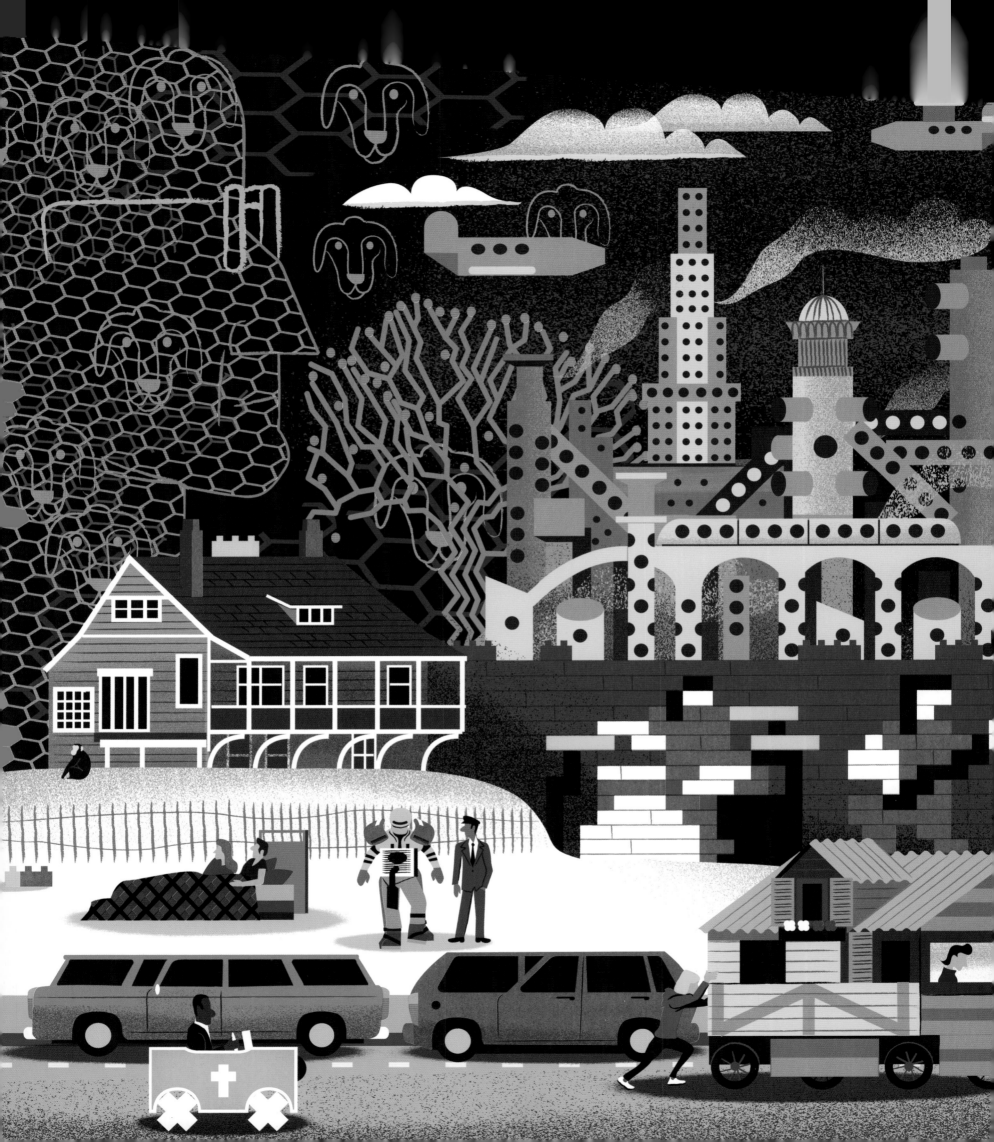

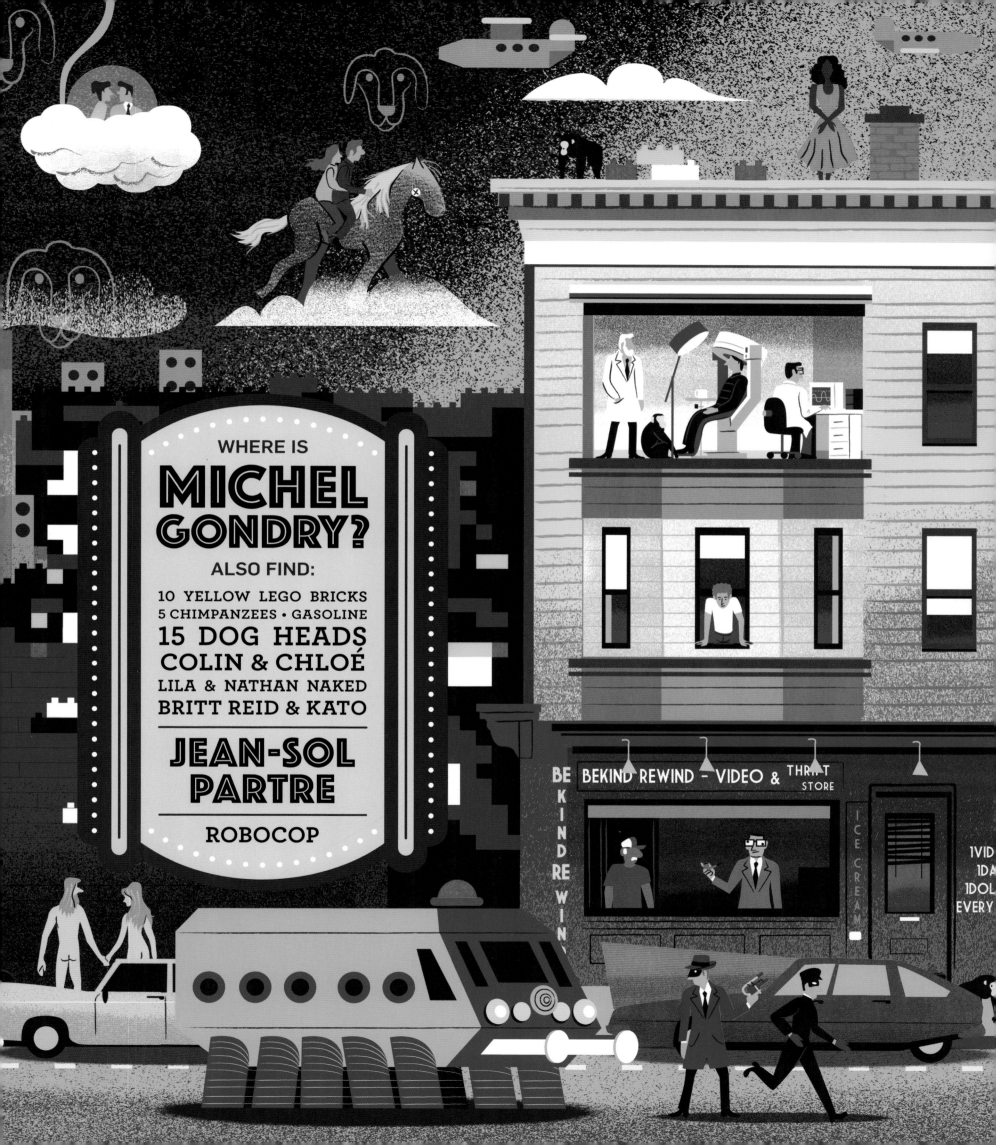

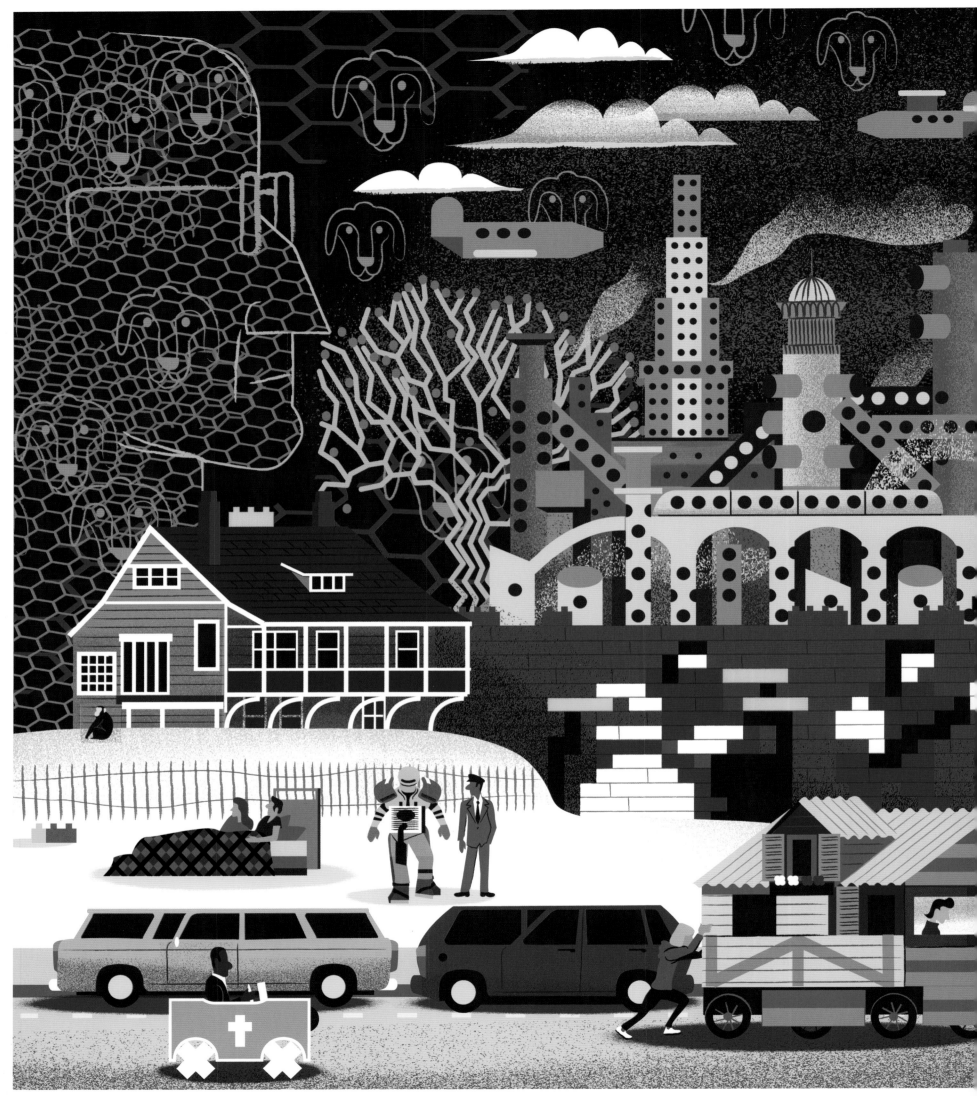

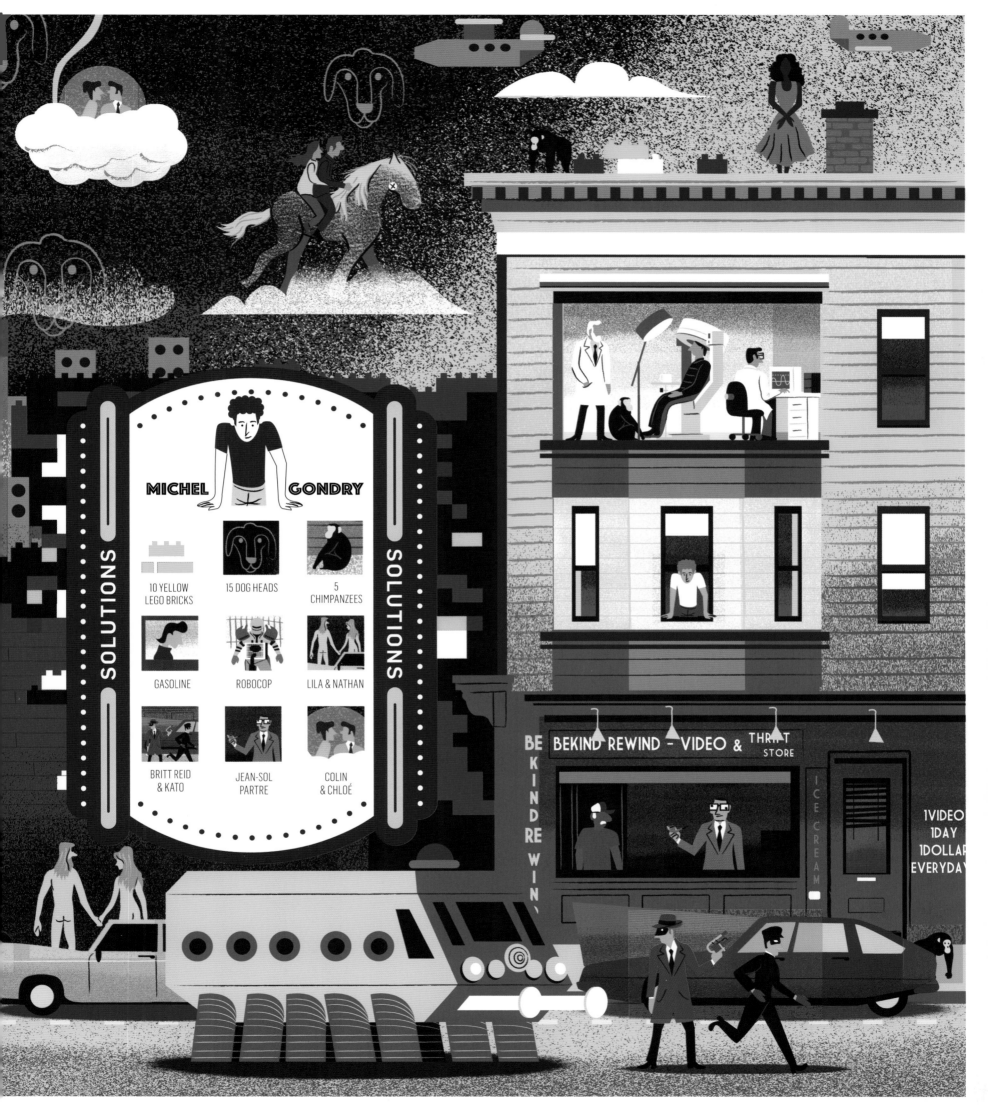

SOLUTIONS

MICHEL GONDRY

10 YELLOW LEGO BRICKS

15 DOG HEADS

5 CHIMPANZEES

GASOLINE

ROBOCOP

LILA & NATHAN

BRITT REID & KATO

JEAN-SOL PARTRE

COLIN & CHLOÉ

SOLUTIONS

BE KIND REWIND - VIDEO & THRIFT STORE

BE KIND REWIN

ICE CREAM

1 VIDEO
1 DAY
1 DOLLAR
EVERYDAY

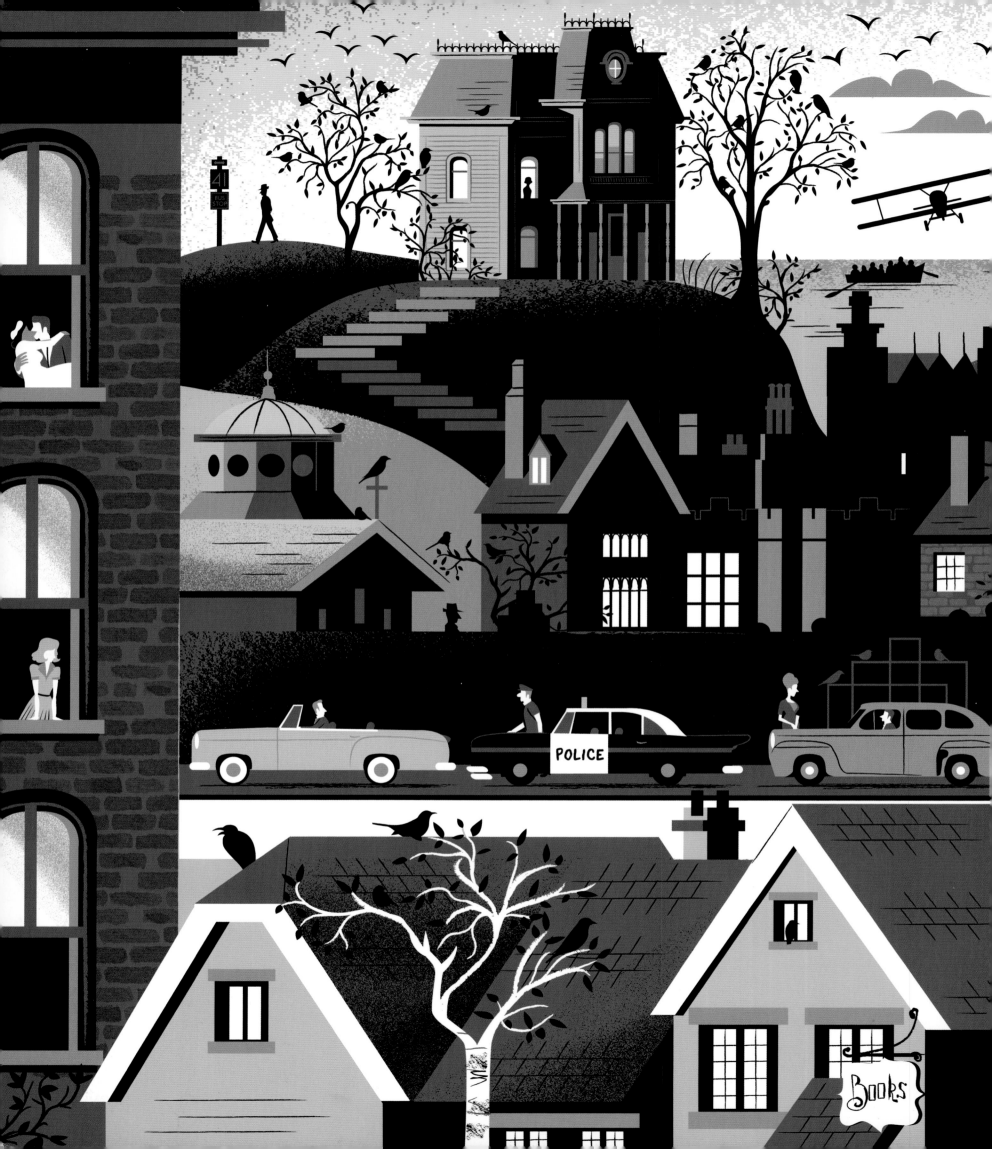

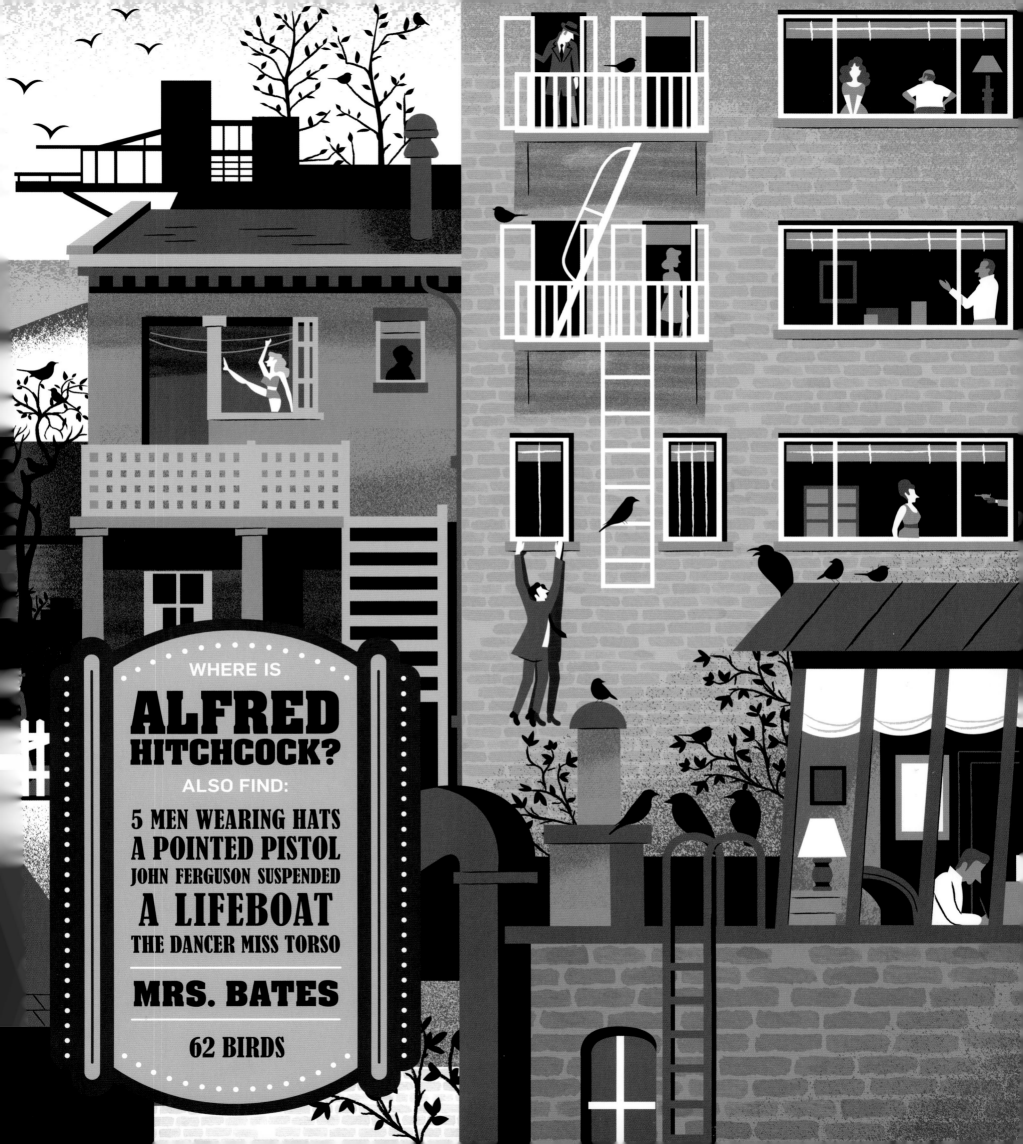

WHERE IS

ALFRED
HITCHCOCK?

ALSO FIND:

5 MEN WEARING HATS
A POINTED PISTOL
JOHN FERGUSON SUSPENDED
A LIFEBOAT
THE DANCER MISS TORSO

MRS. BATES

62 BIRDS

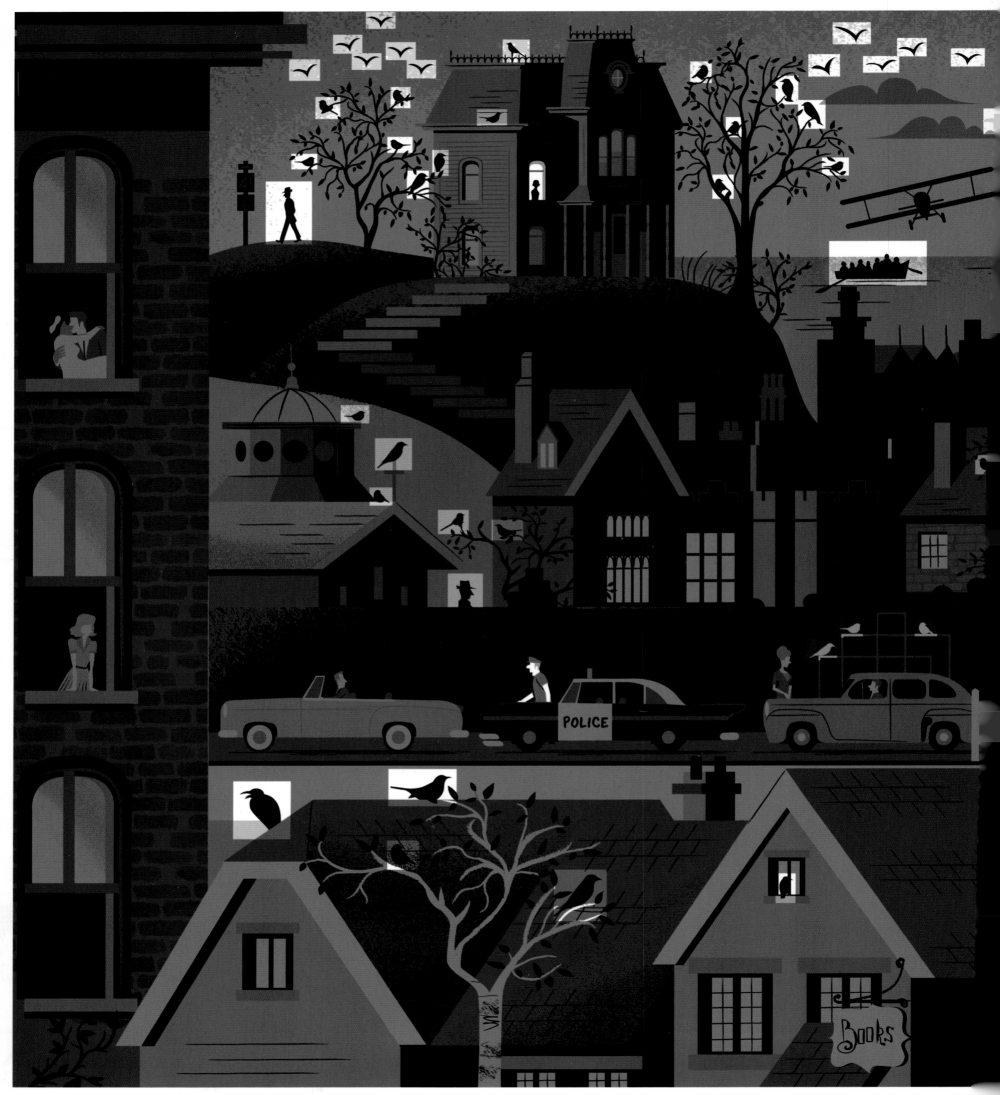

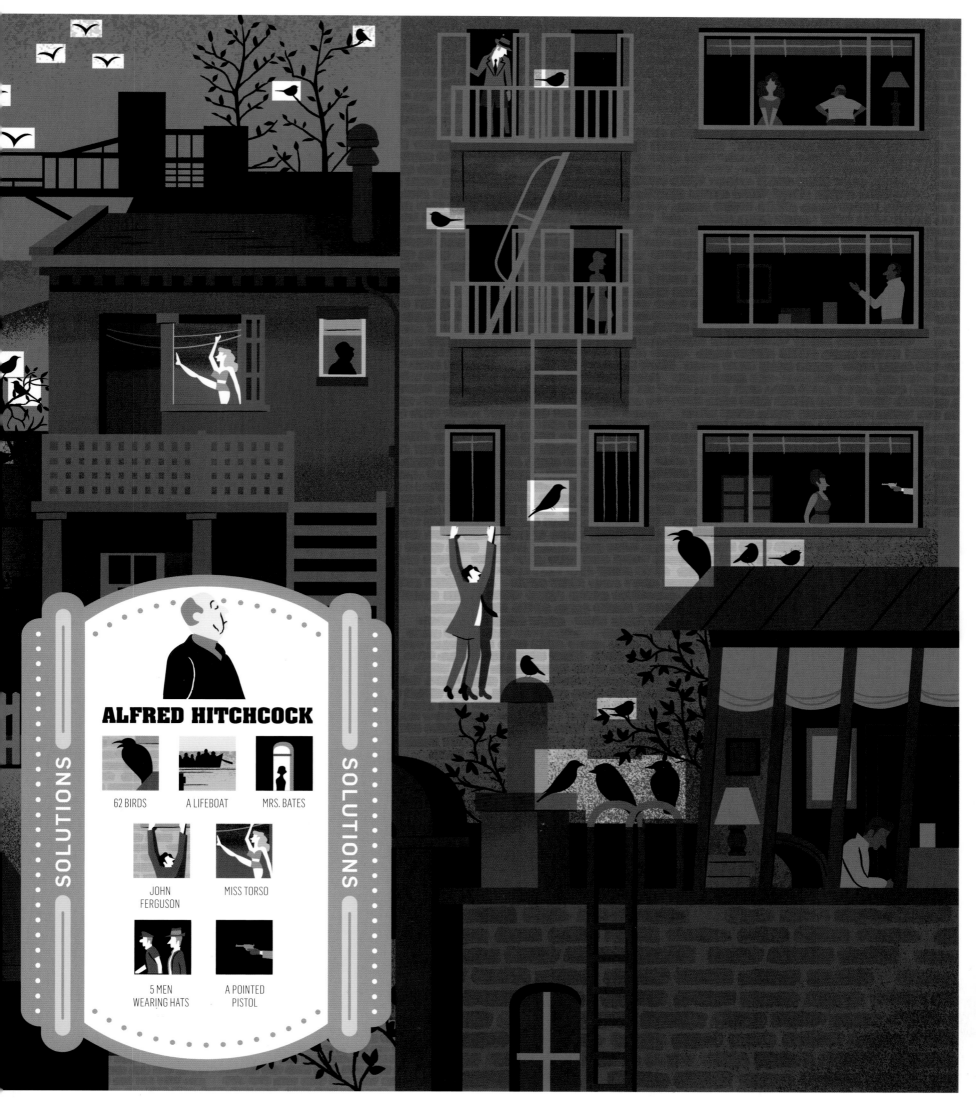

ALFRED HITCHCOCK

SOLUTIONS

SOLUTIONS

62 BIRDS

A LIFEBOAT

MRS. BATES

JOHN FERGUSON

MISS TORSO

5 MEN WEARING HATS

A POINTED PISTOL

25

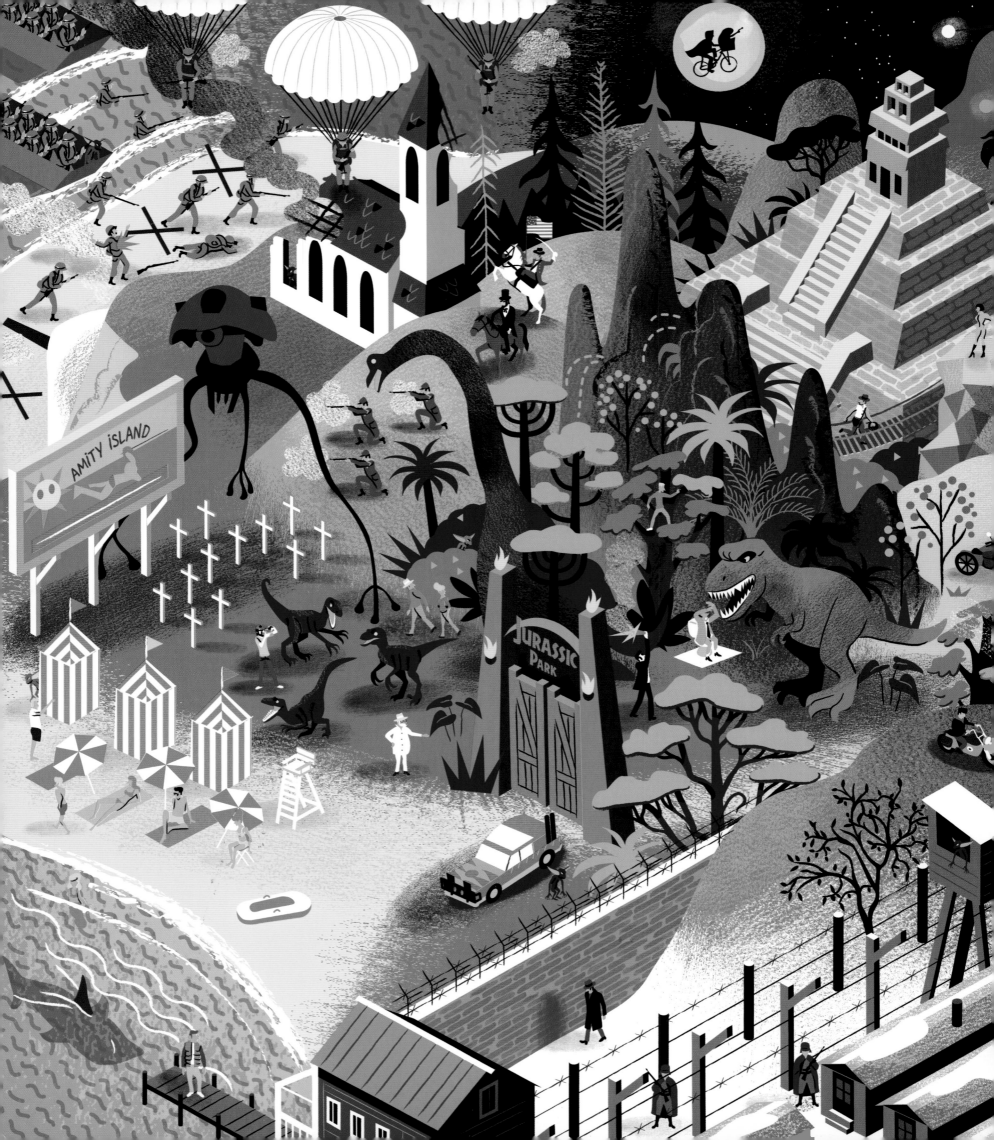

AMITY ISLAND

JURASSIC PARK

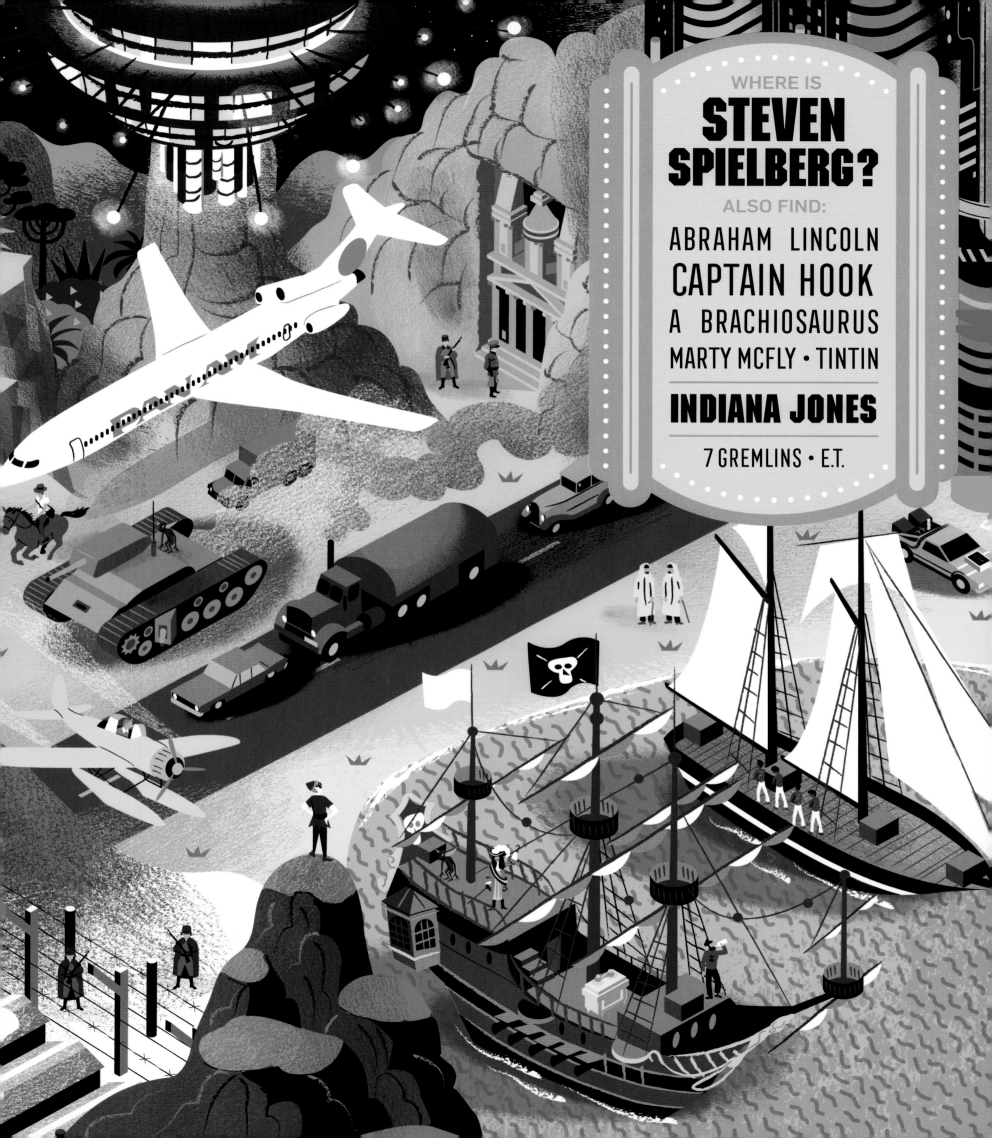

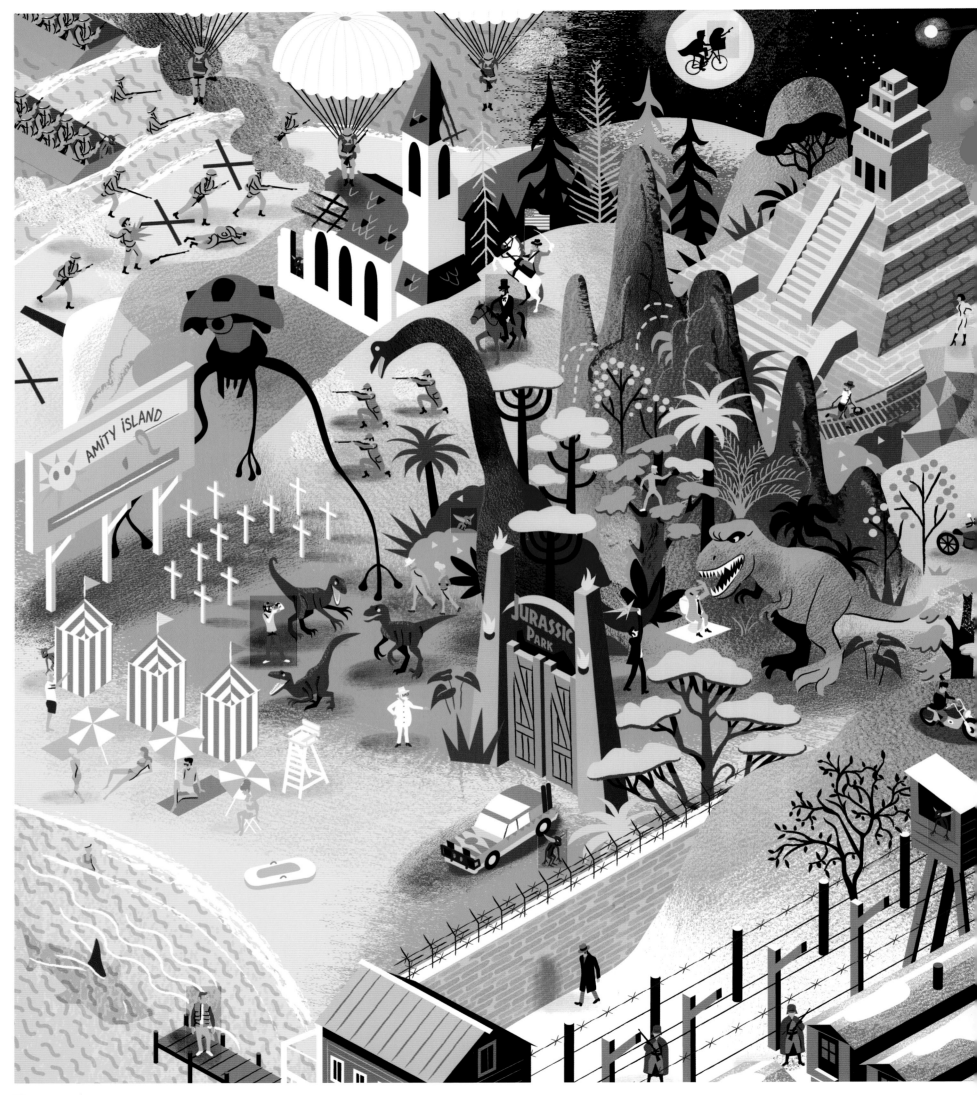

AMITY ISLAND

JURASSIC
PARK

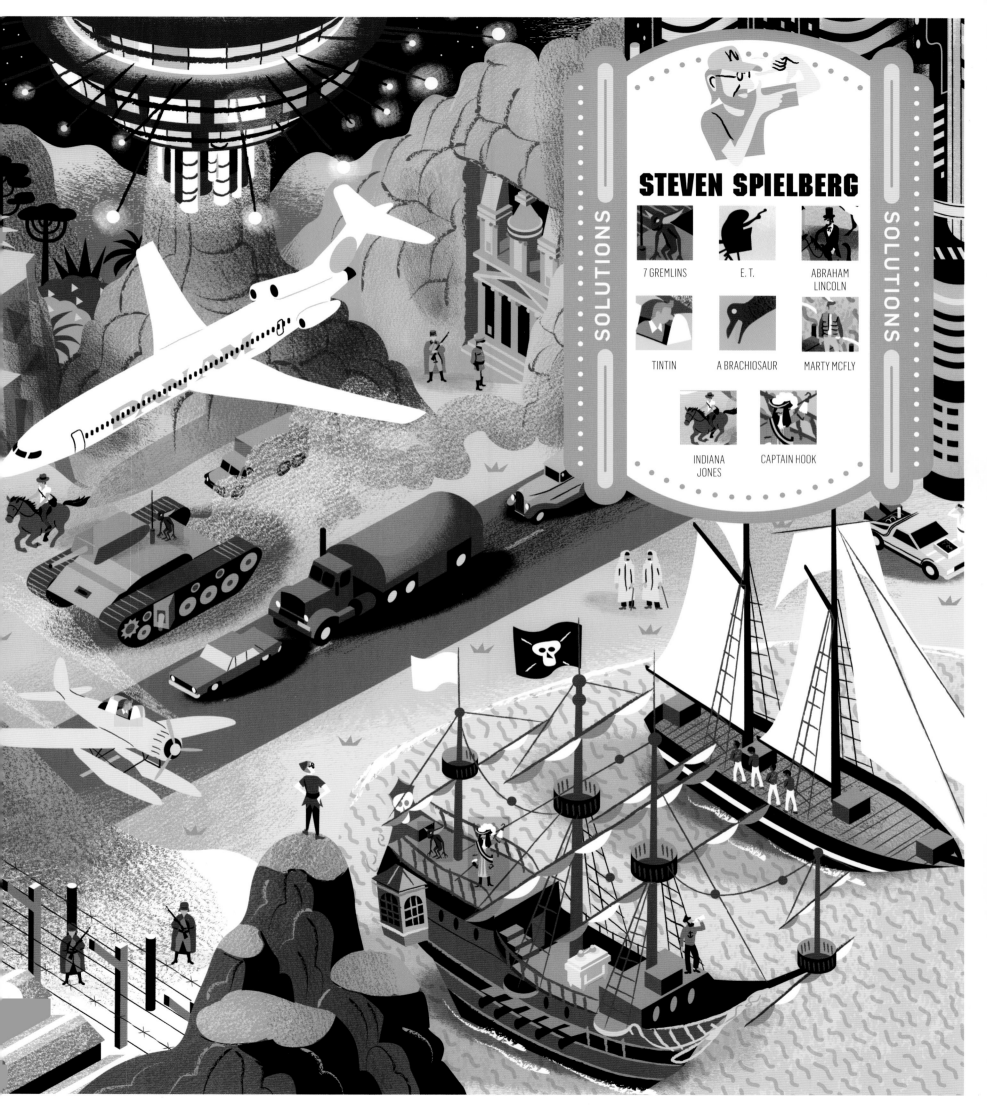

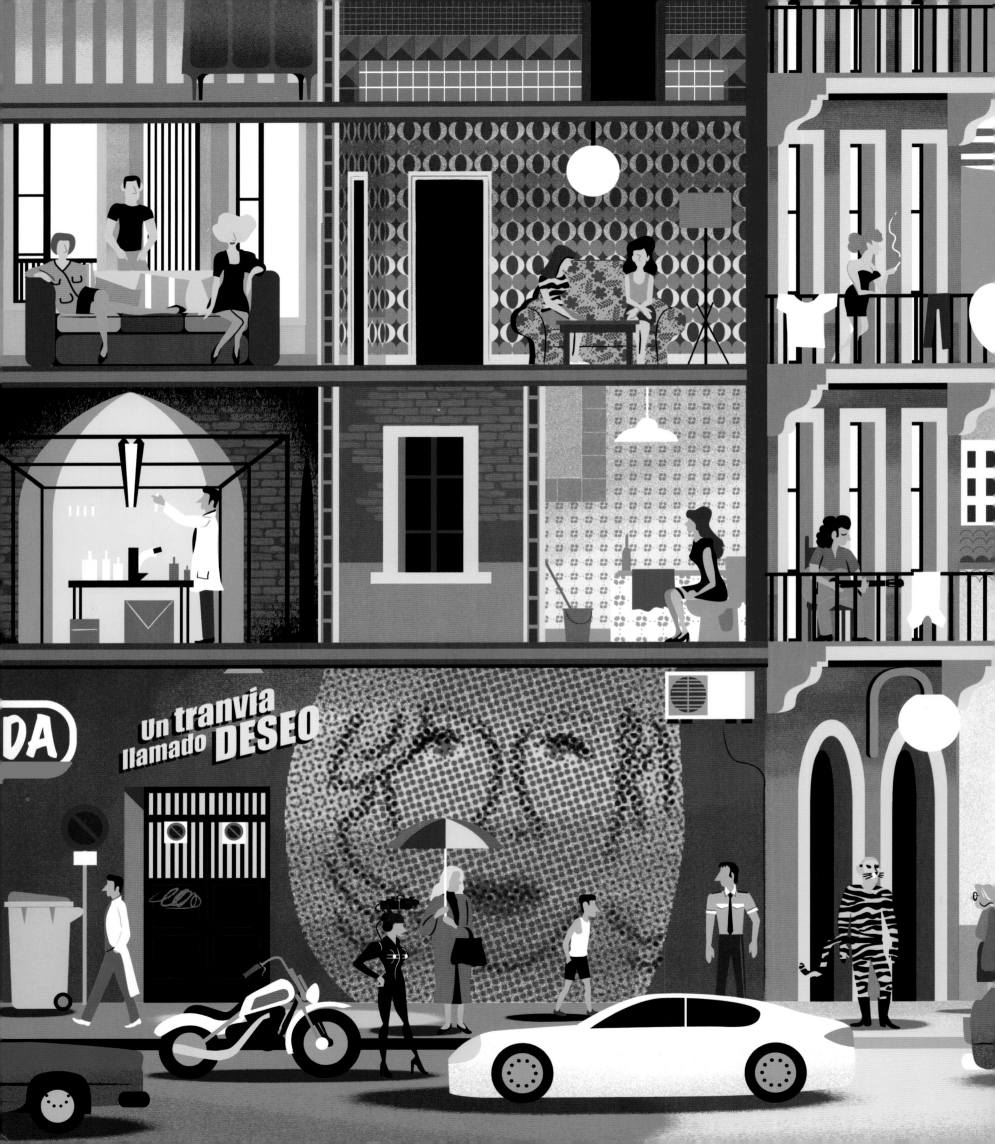

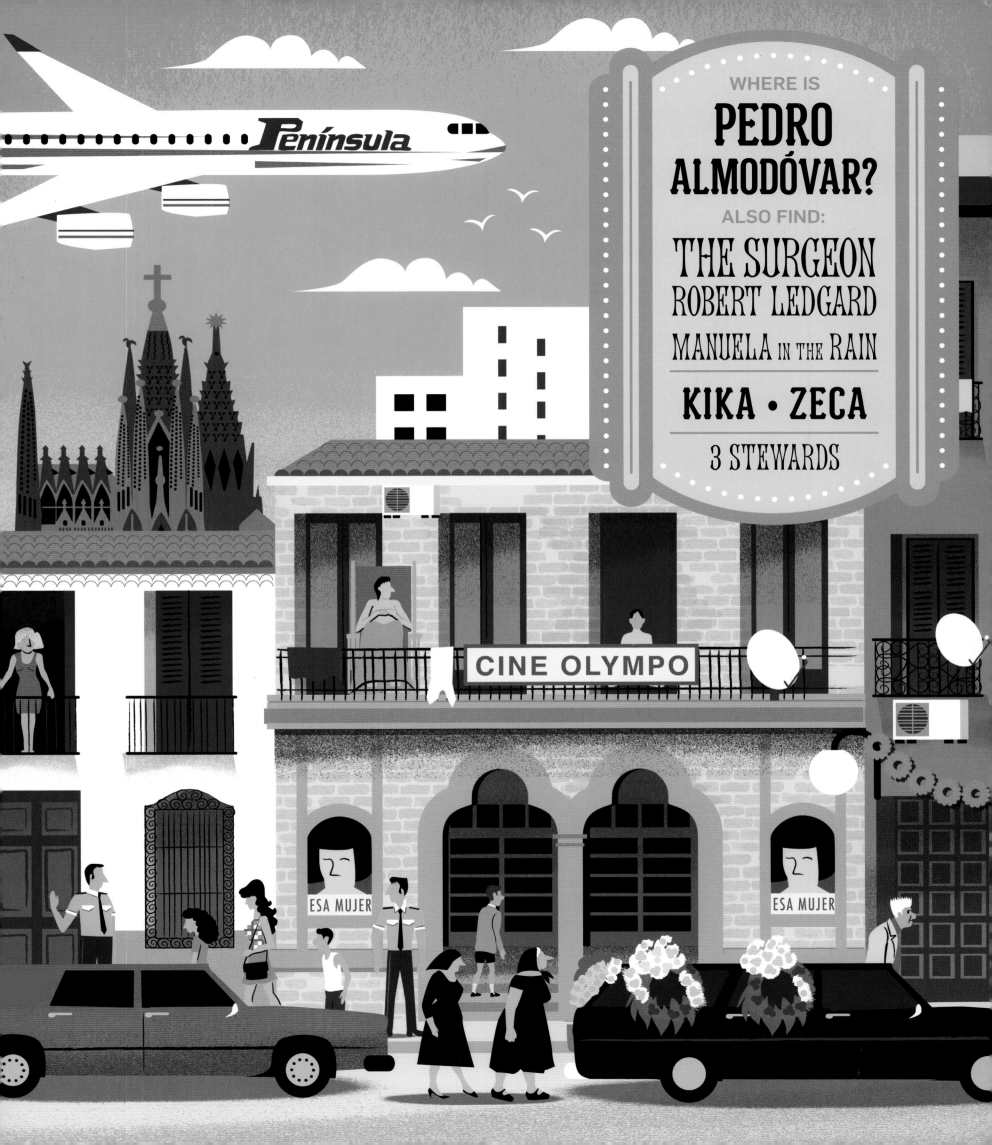

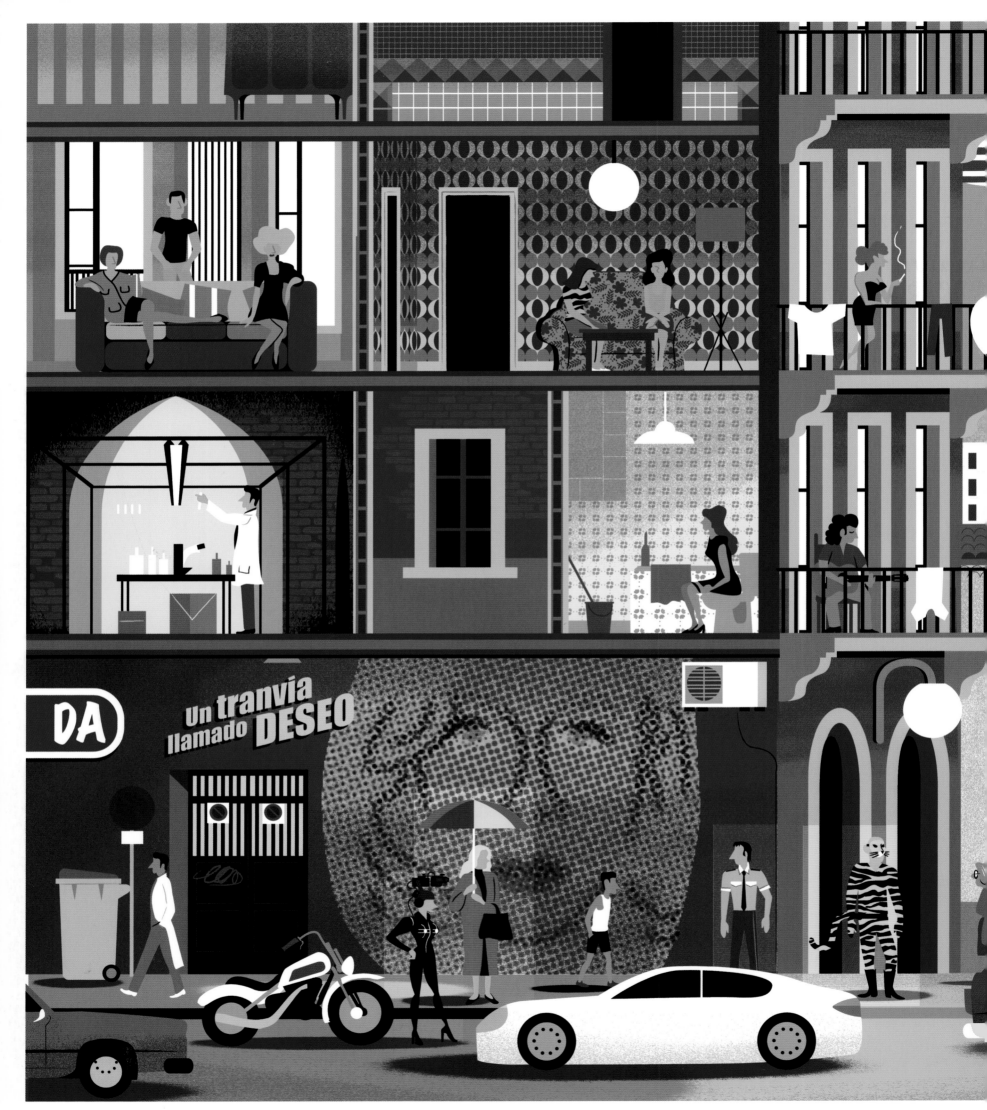

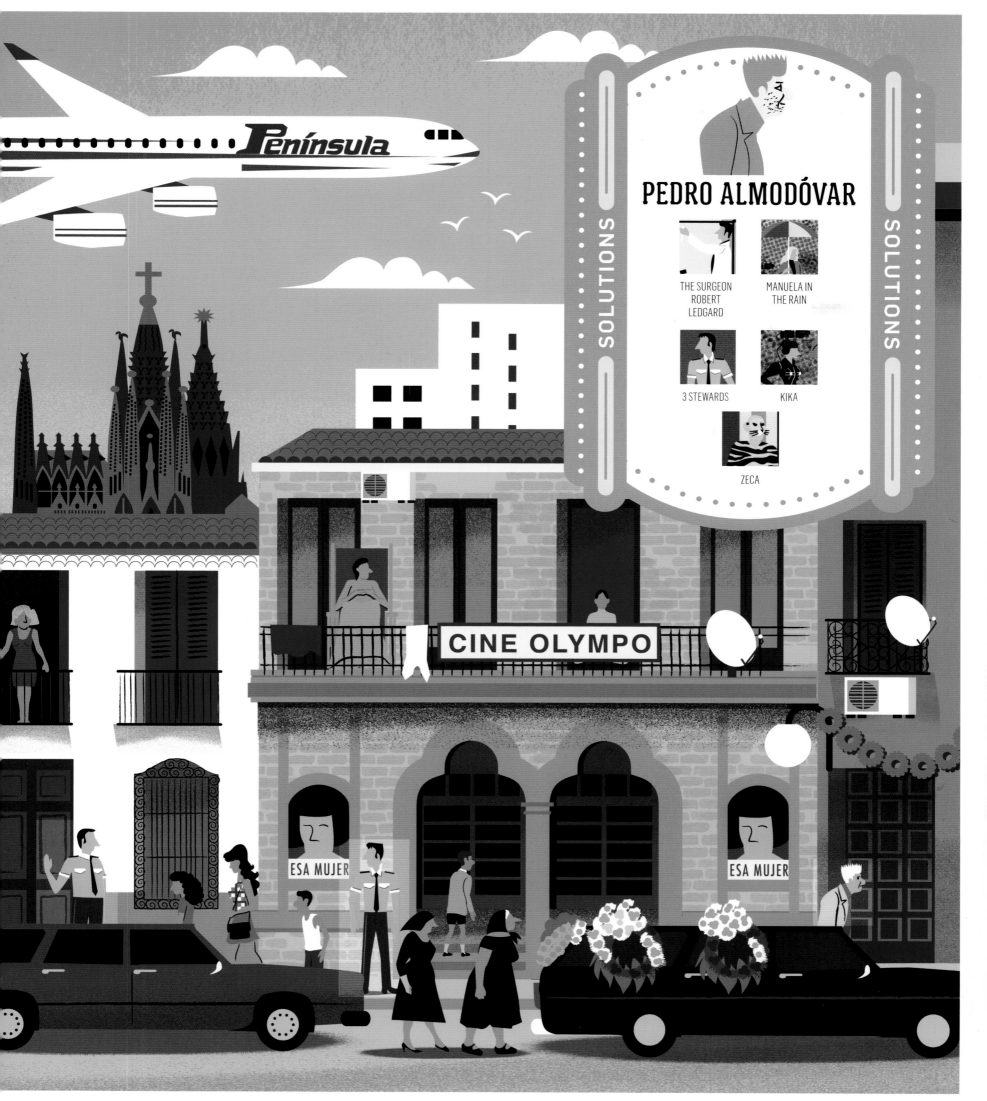

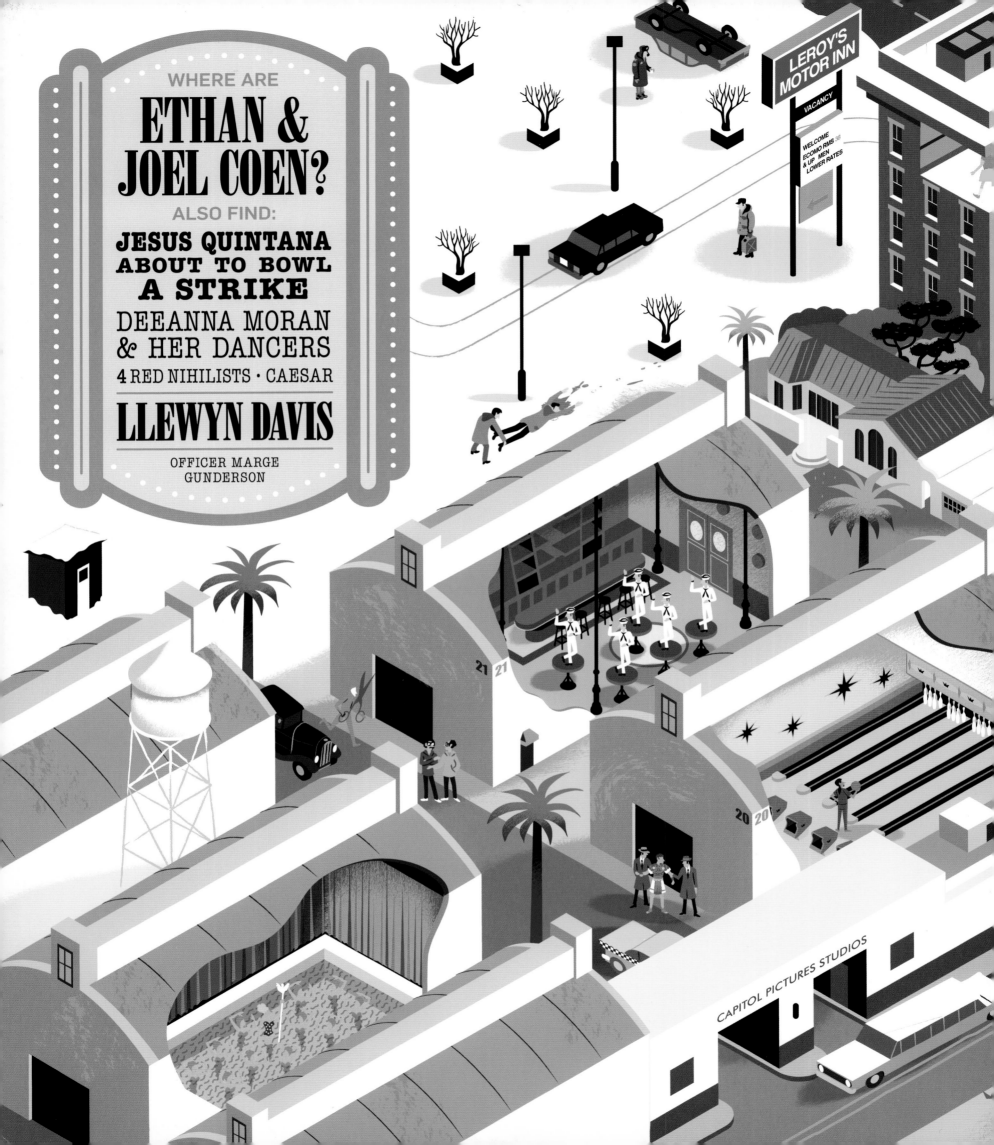

WHERE ARE
ETHAN &
JOEL COEN?
ALSO FIND:
JESUS QUINTANA
ABOUT TO BOWL
A STRIKE
DEEANNA MORAN
& HER DANCERS
4 RED NIHILISTS · CAESAR
LLEWYN DAVIS
OFFICER MARGE
GUNDERSON

LEROY'S
MOTOR INN

VACANCY

WELCOME
ECOMO RMS 38
& UP MEN
LOWER RATES

CAPITOL PICTURES STUDIOS

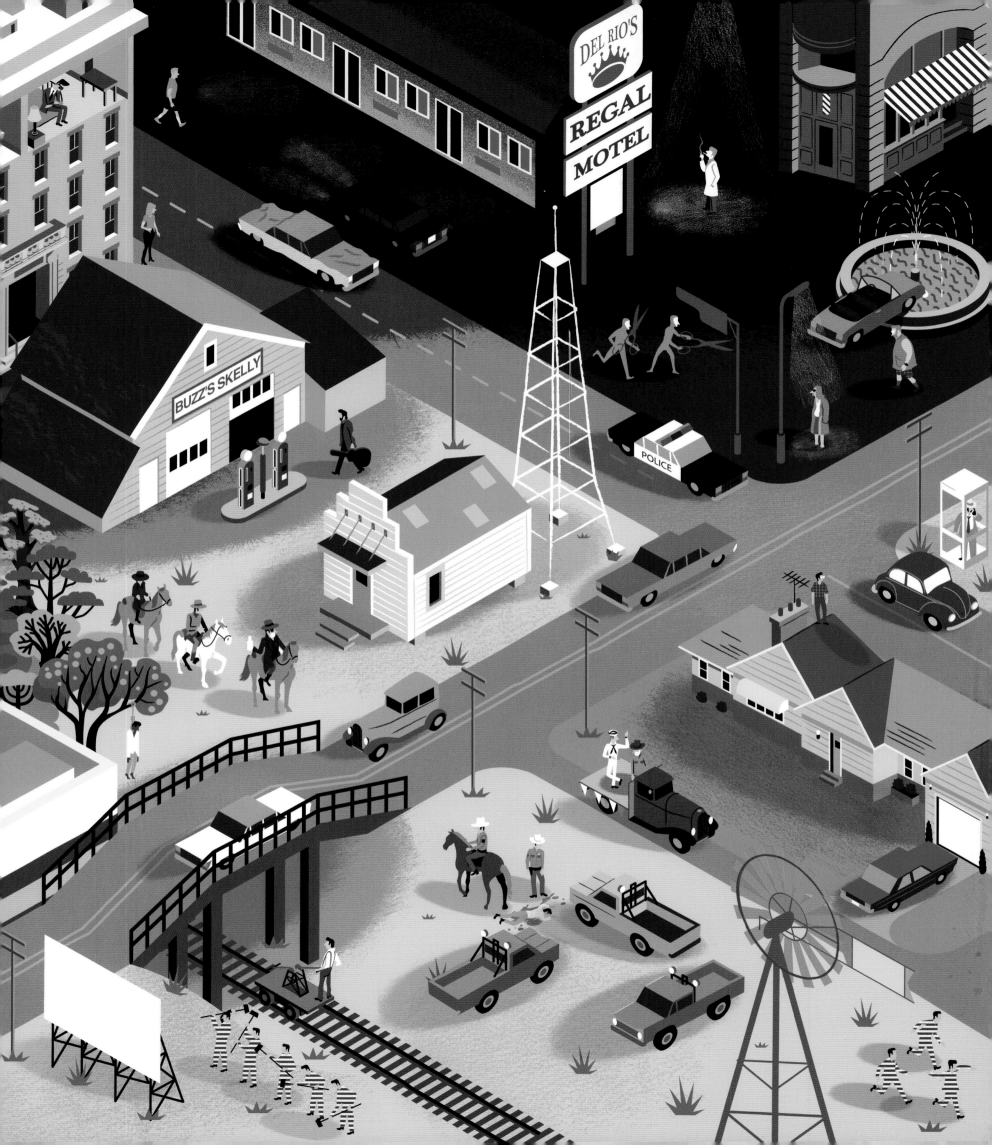

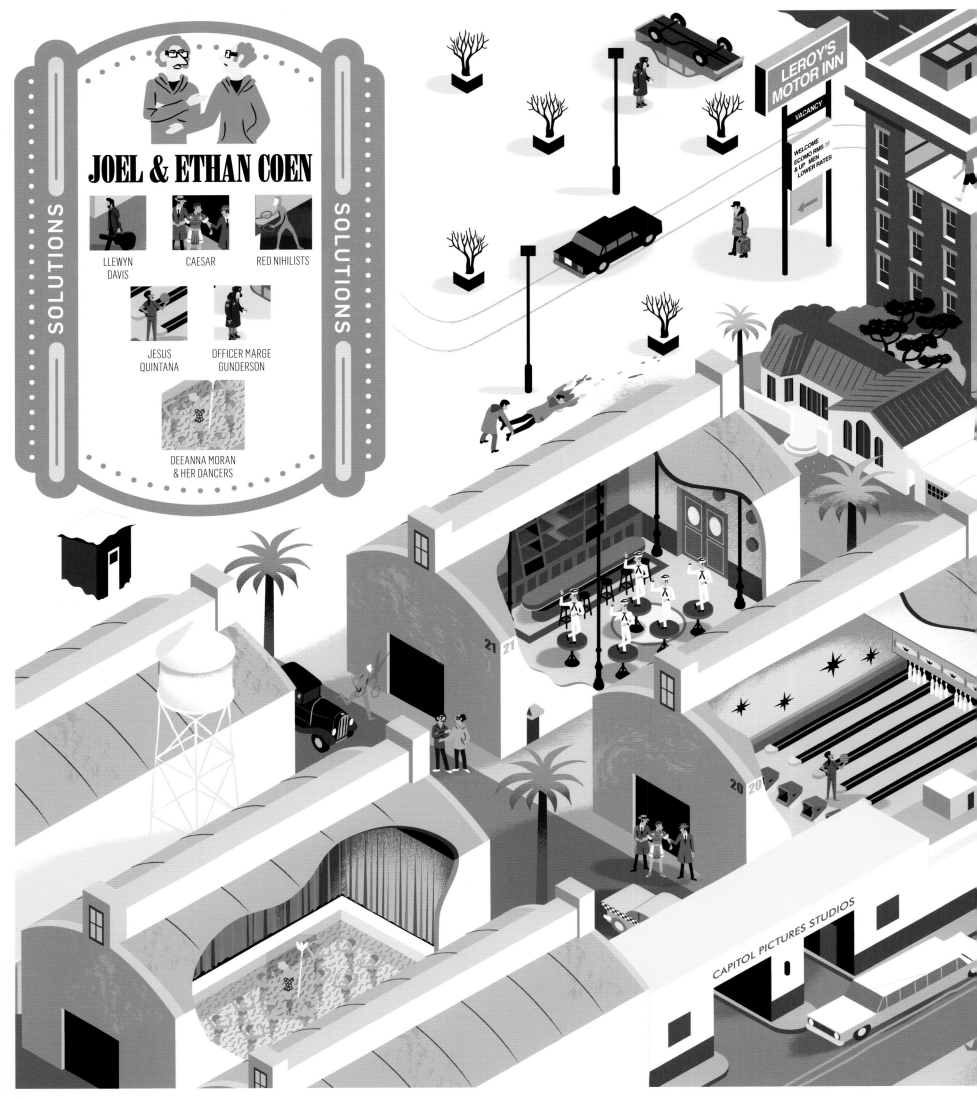

JOEL & ETHAN COEN

SOLUTIONS

SOLUTIONS

LLEWYN DAVIS

CAESAR

RED NIHILISTS

JESUS QUINTANA

OFFICER MARGE GUNDERSON

DEEANNA MORAN & HER DANCERS

LEROY'S MOTOR INN

VACANCY

WELCOME
ECOMO RMS 38
& UP MEN
LOWER RATES

CAPITOL PICTURES STUDIOS

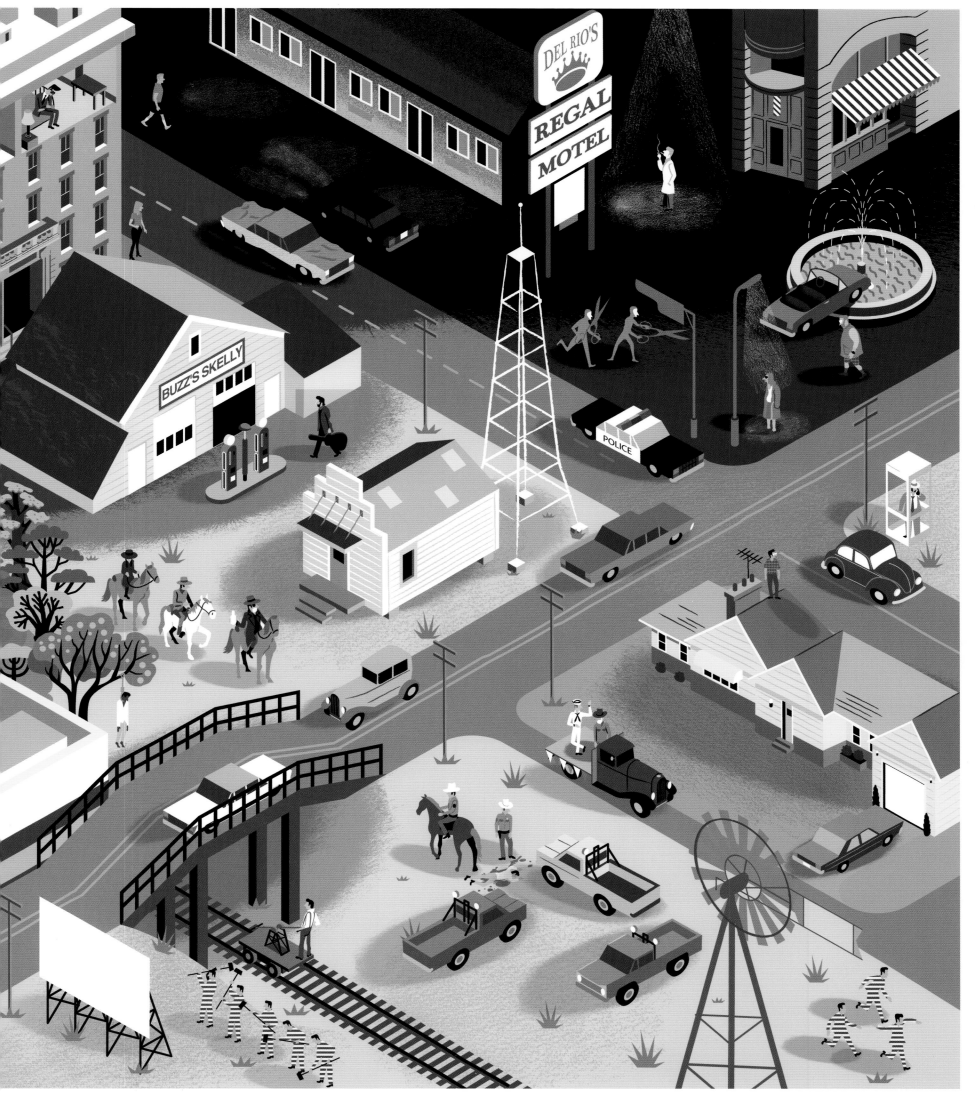

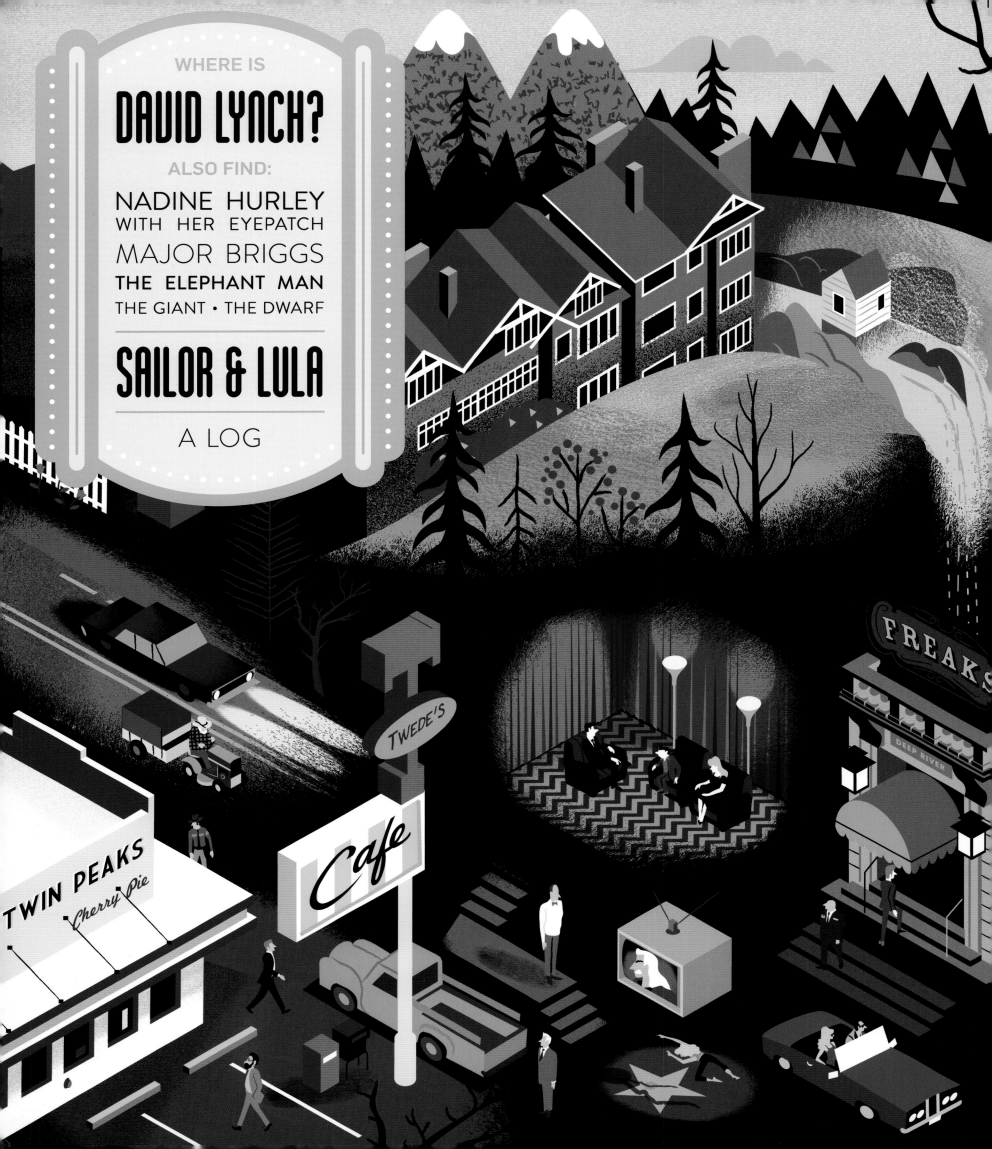

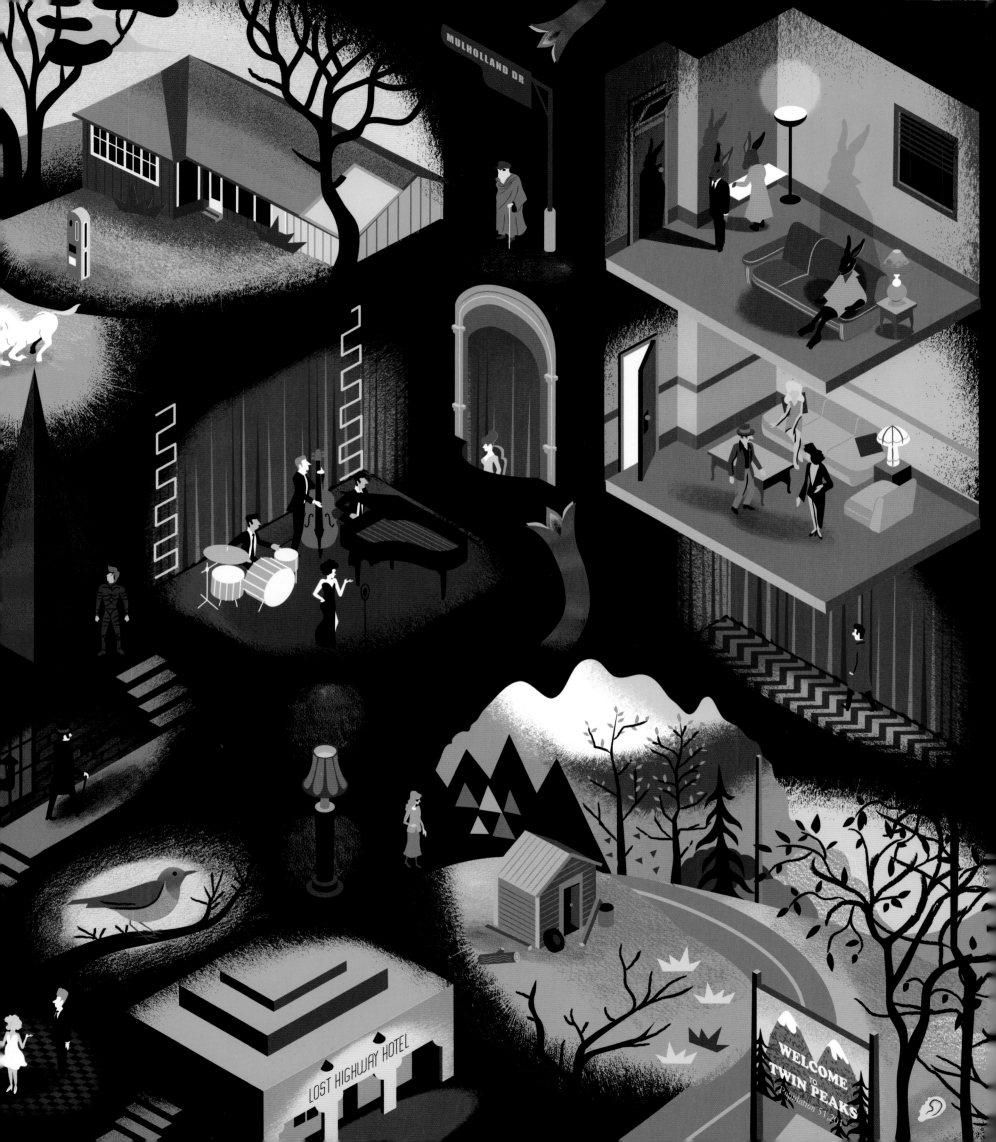

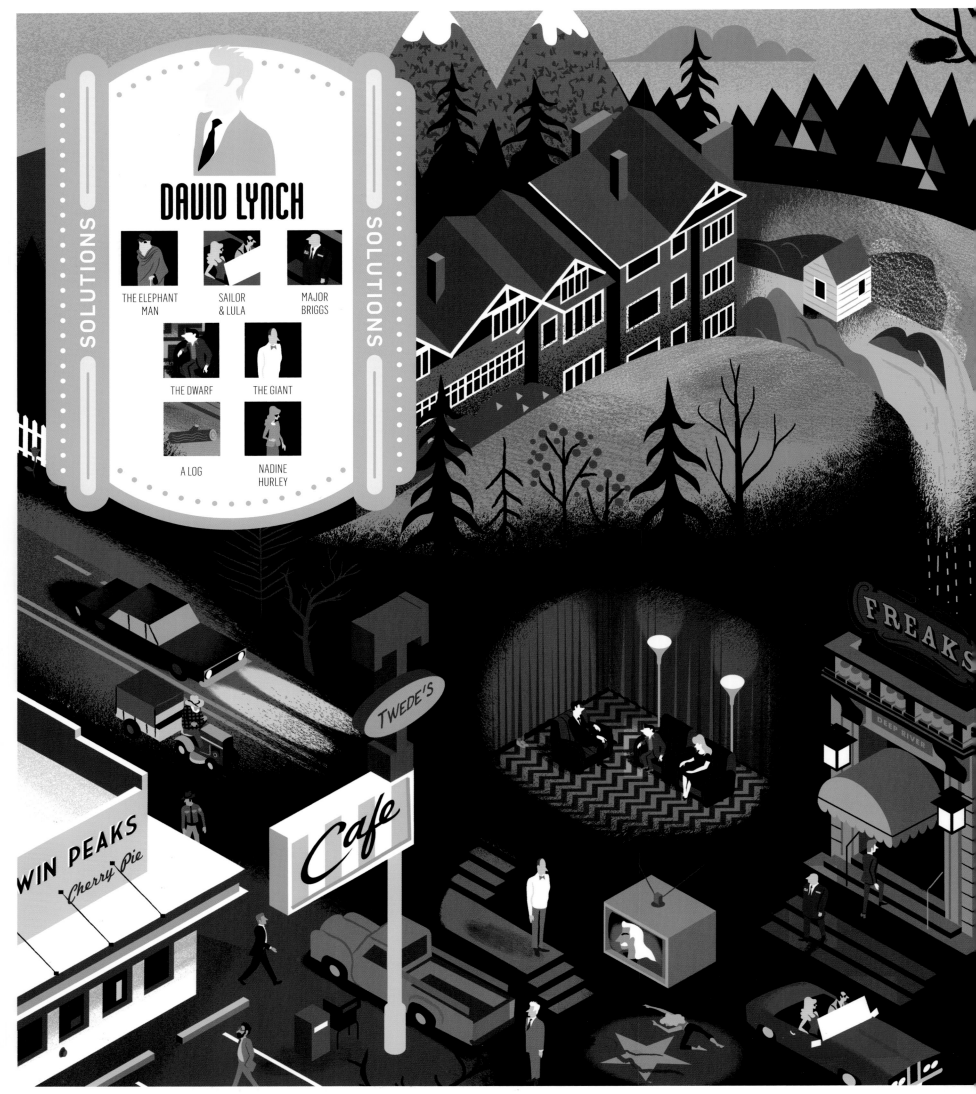

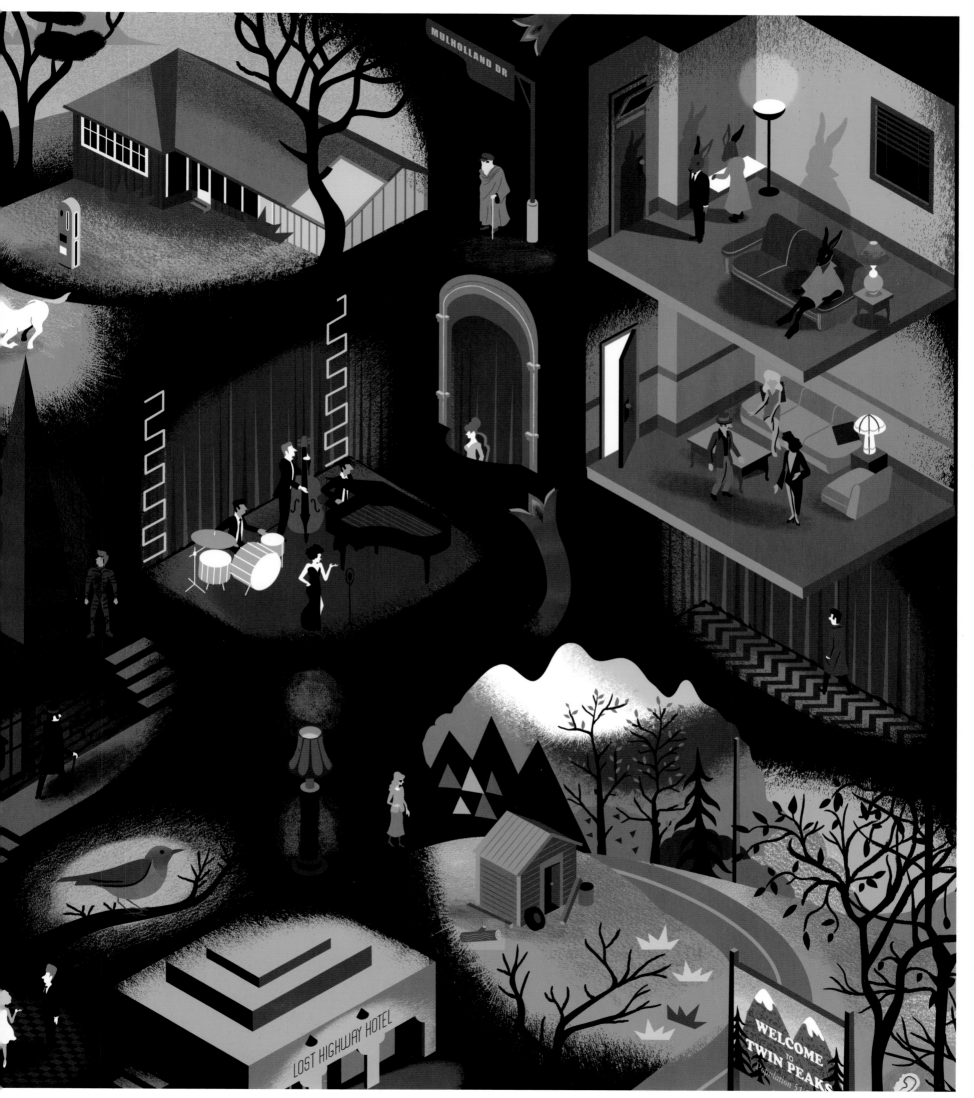

41

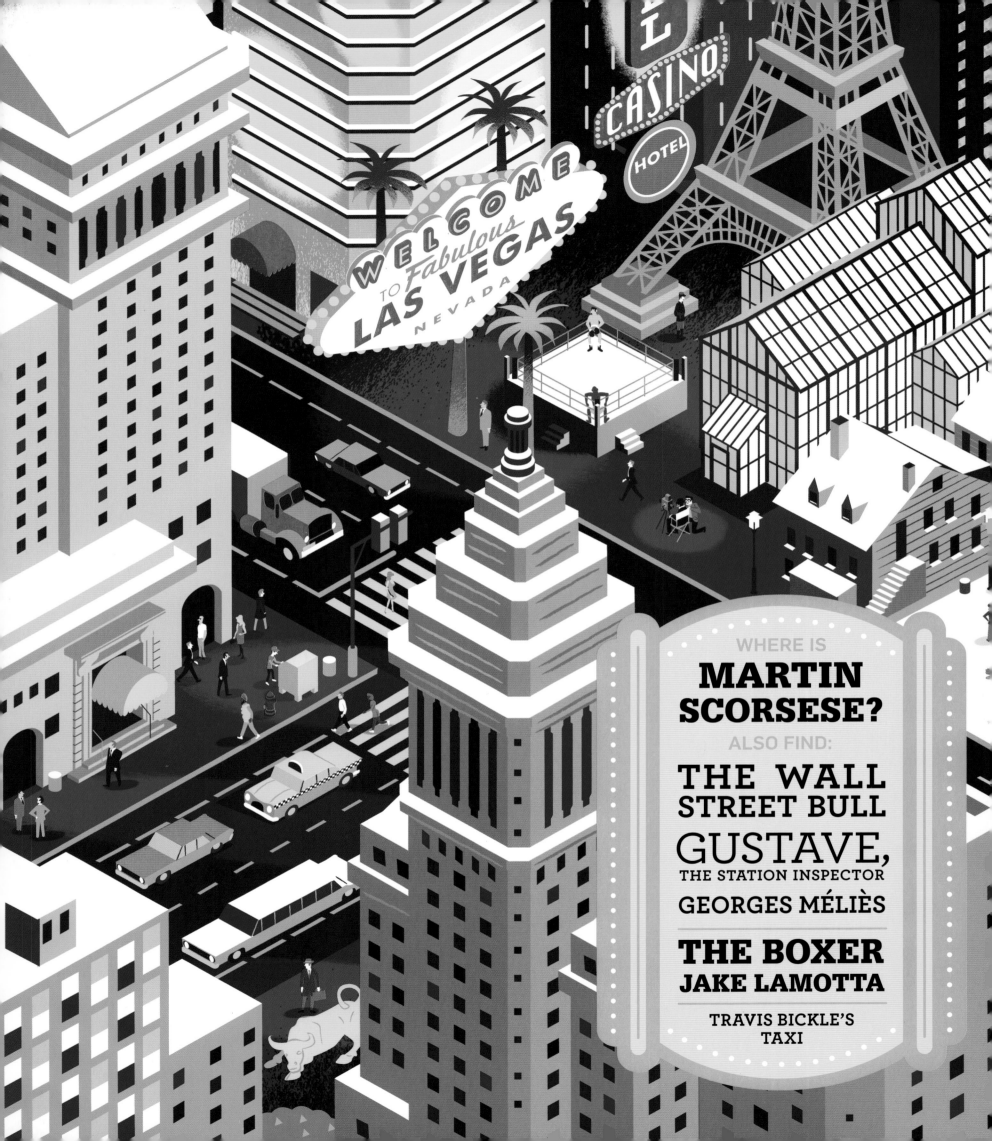

WHERE IS
MARTIN SCORSESE?
ALSO FIND:
THE WALL STREET BULL
GUSTAVE, THE STATION INSPECTOR
GEORGES MÉLIÈS
THE BOXER JAKE LAMOTTA
TRAVIS BICKLE'S TAXI

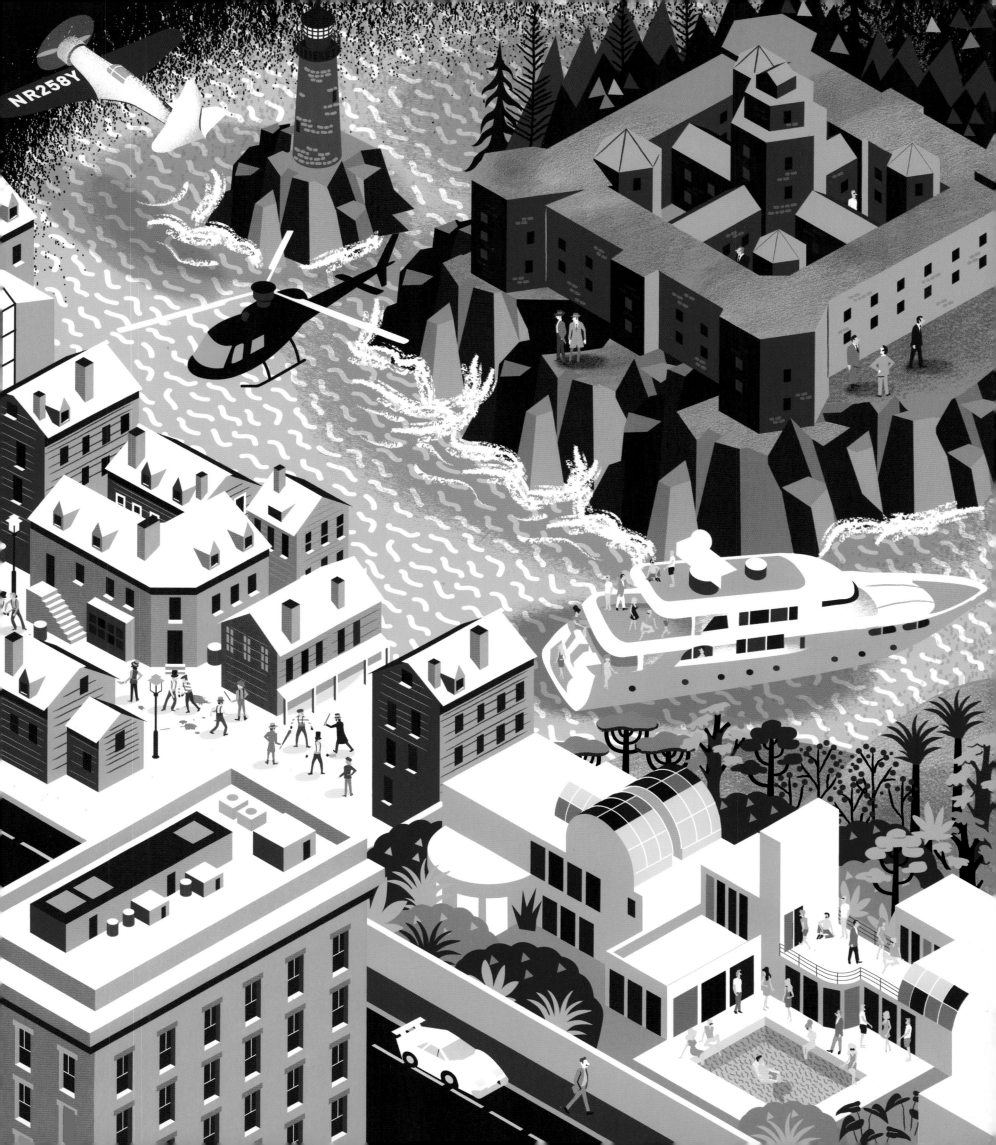

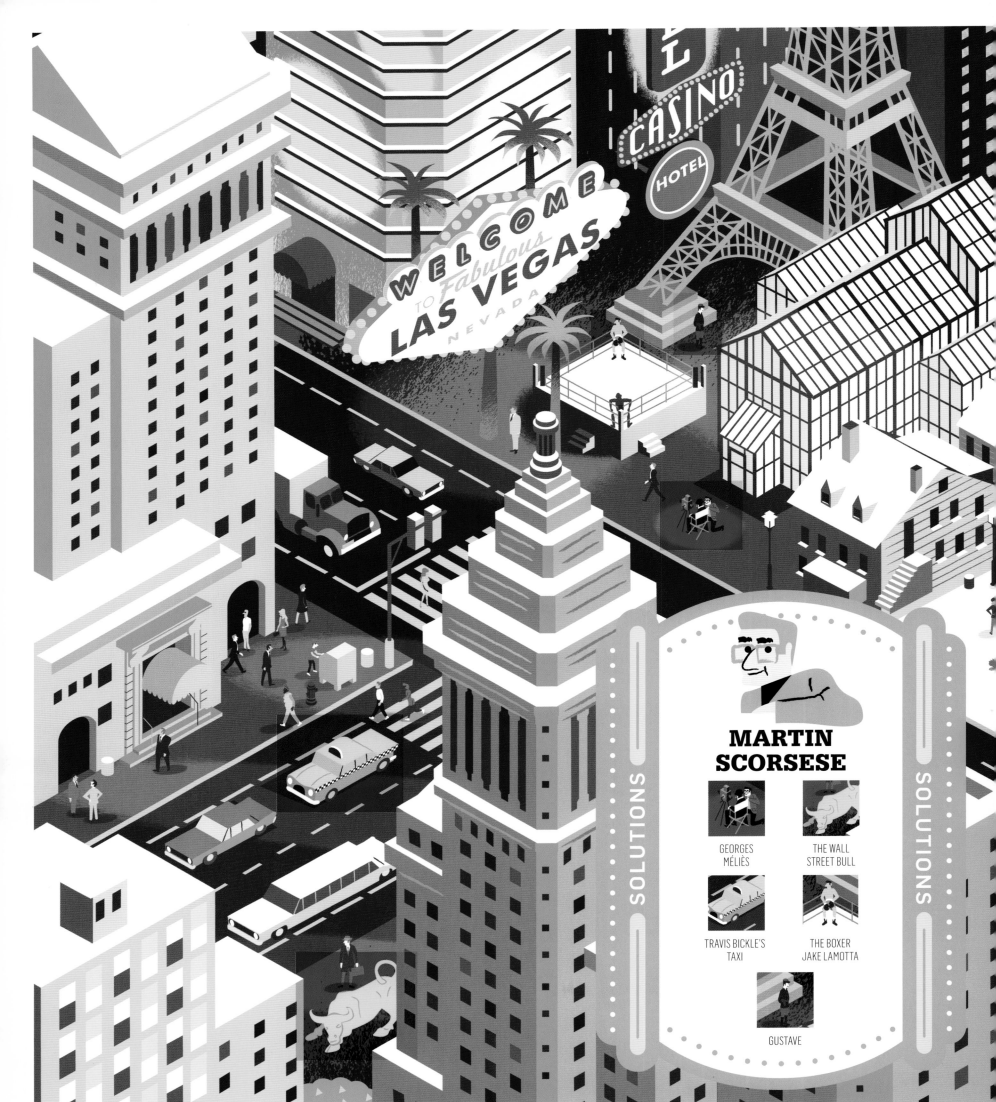

SOLUTIONS

SOLUTIONS

MARTIN SCORSESE

GEORGES MÉLIÈS

THE WALL STREET BULL

TRAVIS BICKLE'S TAXI

THE BOXER JAKE LAMOTTA

GUSTAVE

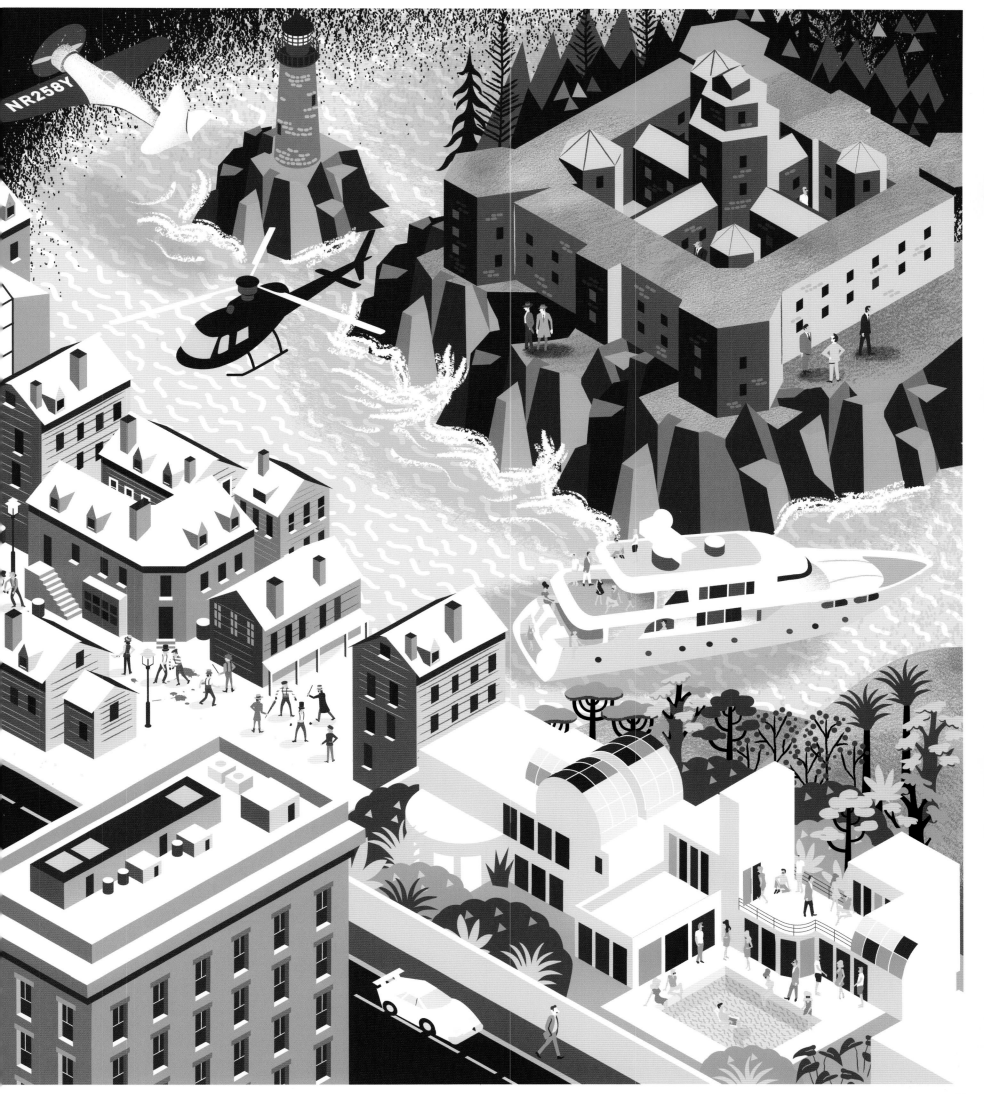

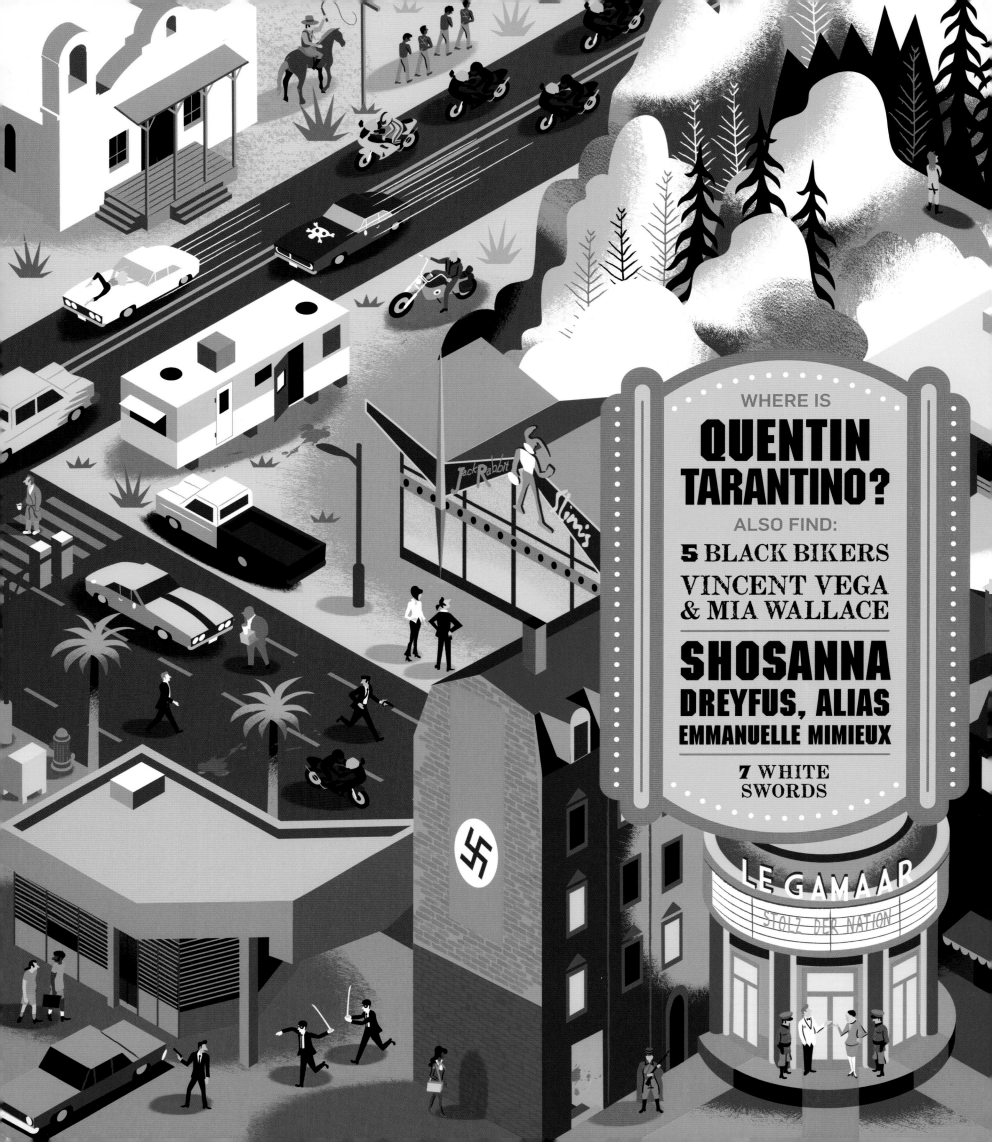

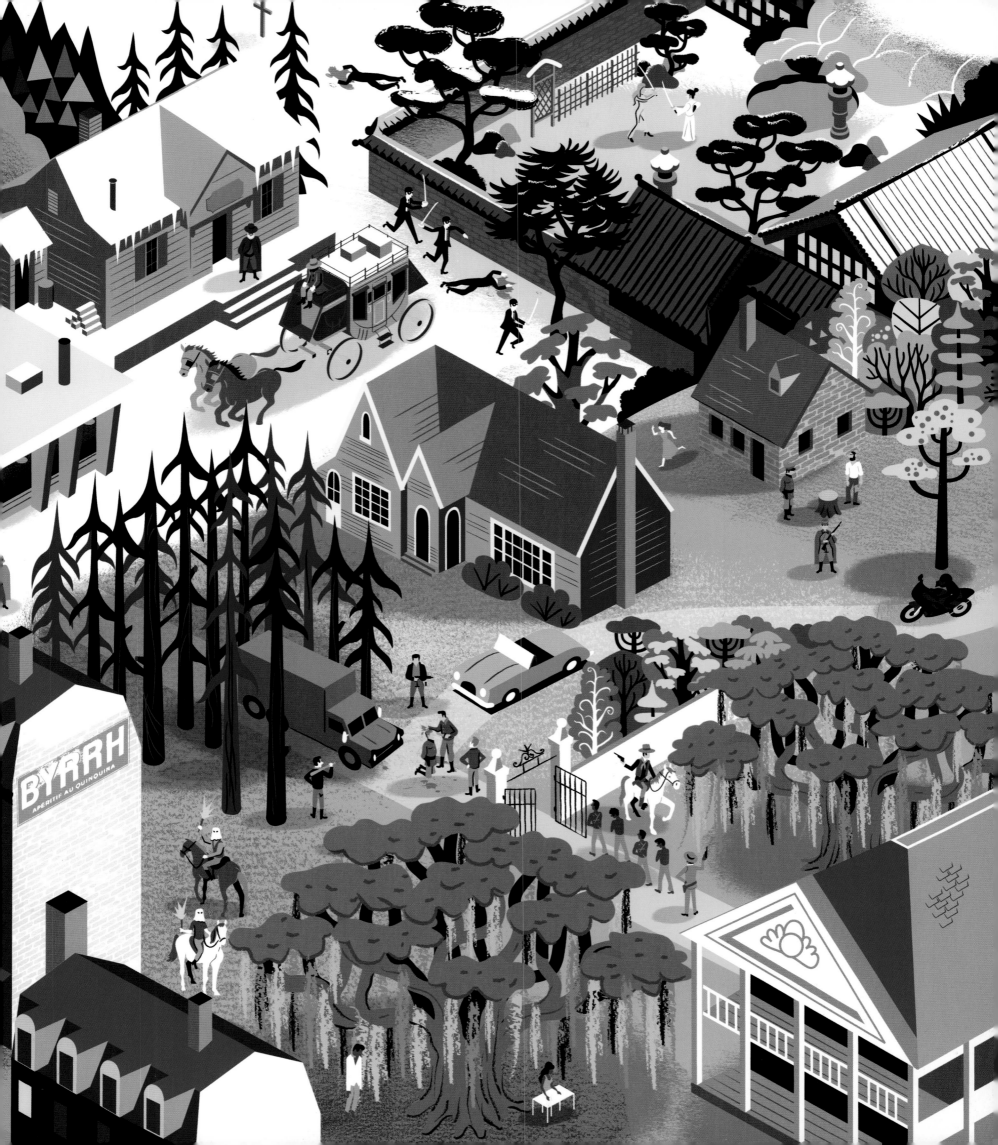

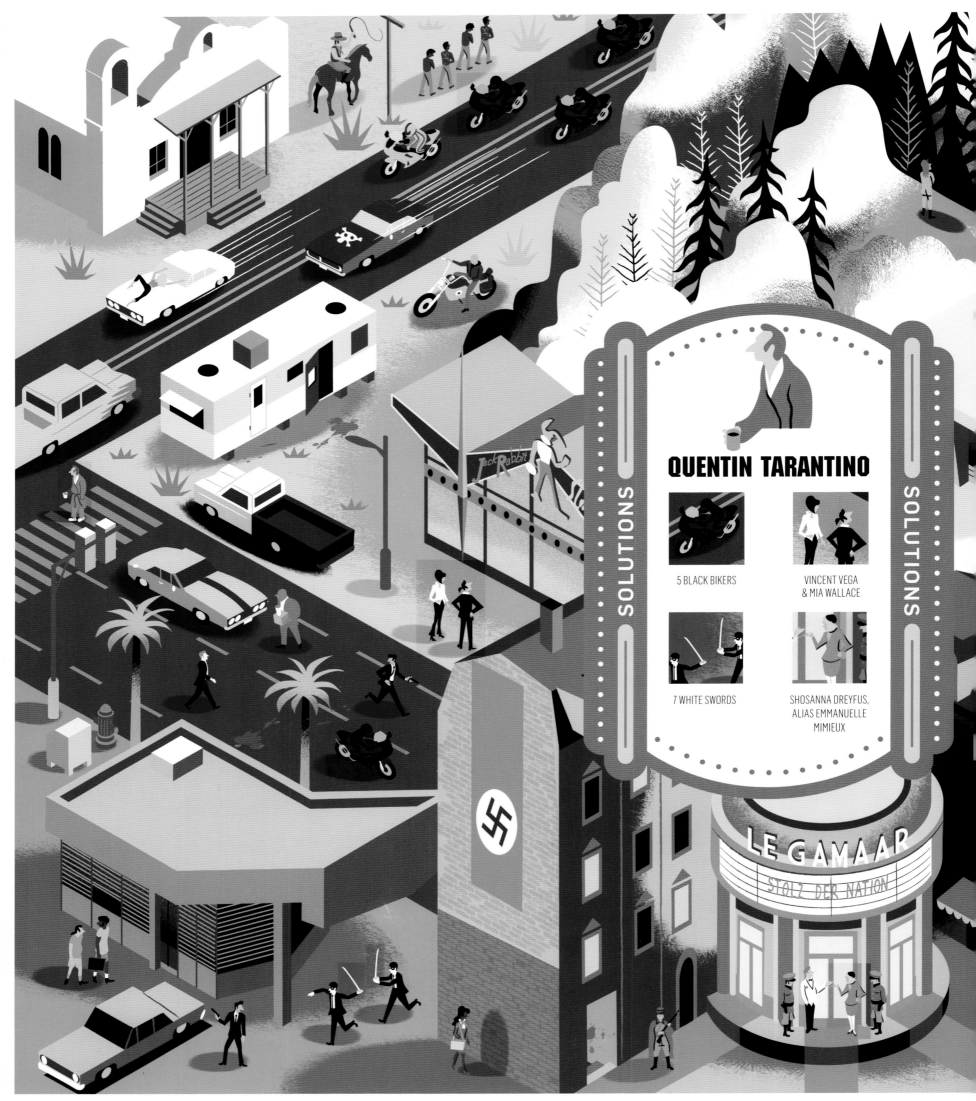

SOLUTIONS

QUENTIN TARANTINO

5 BLACK BIKERS

VINCENT VEGA
& MIA WALLACE

7 WHITE SWORDS

SHOSANNA DREYFUS,
ALIAS EMMANUELLE
MIMIEUX

48

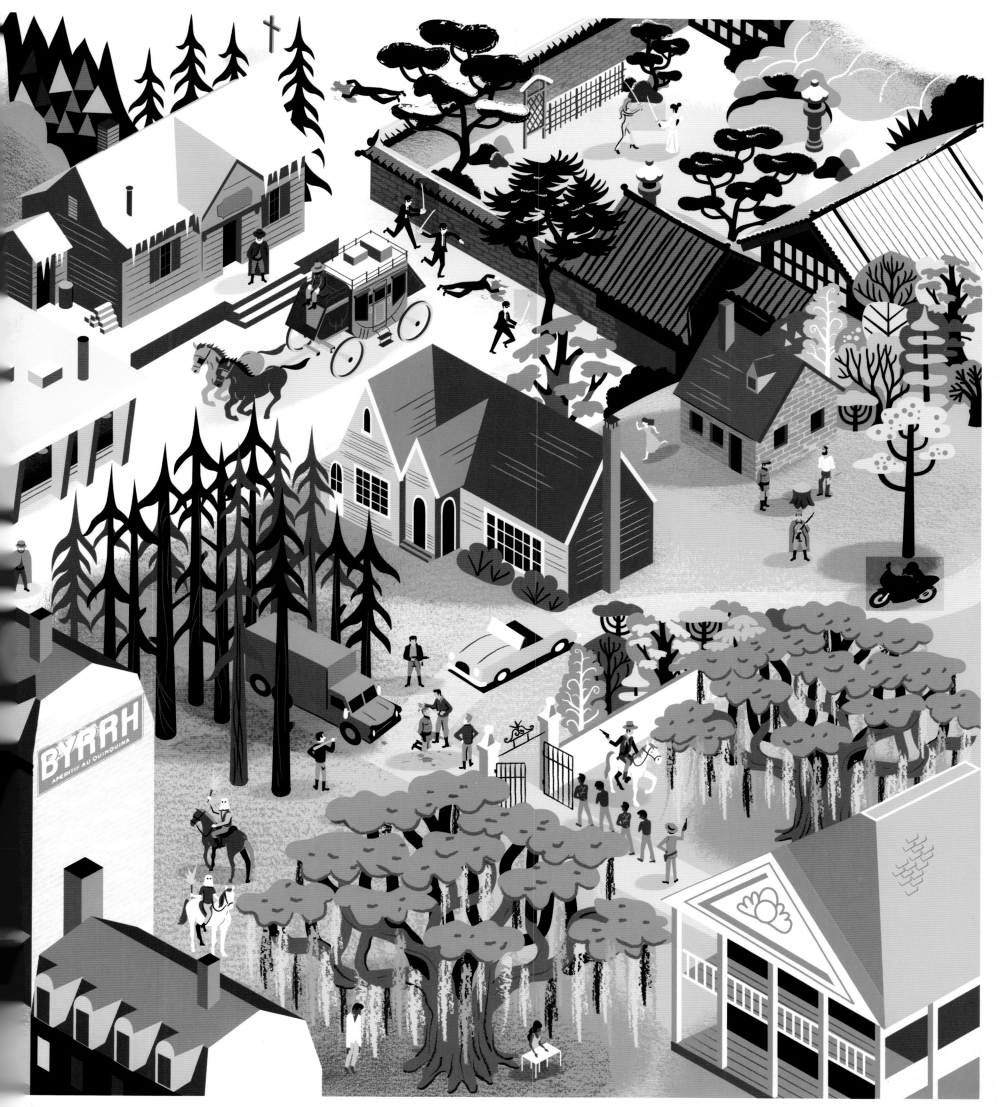

Pages 6–7

Beetlejuice © Tim Burton, Michael *McDowell*, Larry Wilson, Warren *Skaaren*, The *Geffen Company*, 1988.

Batman © Tim Burton, Bob Kane, Sam Hamm, Warren *Skaaren*, Warner *Bros.*, The *Guber-Peters Company*, *PolyGram Filmed* Entertainment, 1999.

Edward Scissorhands © Tim Burton, Caroline Thompson, *Twentieth* Century Fox Film Corporation, 1990.

Batman Returns © Tim Burton, Bob Kane, Daniel Waters, Sam Hamm, Warner *Bros.*, *PolyGram Filmed* Entertainment, 1992.

Ed Wood © Tim Burton, Rudolph Grey, Scott Alexander, Larry *Karaszewski, Touchstone Pictures*, 1994.

The Nightmare Before Christmas © Henry Selick, Tim Burton, Michael McDowell, Caroline Thompson, Touchstone Pictures, Skellington Productions Inc., Tim Burton Productions, Walt Disney Pictures, 1993.

Batman Forever © Joel Schumacher, Bob Kane, Lee Batchler, Janet Scott Batchler, Akiva Goldsman, Warner Bros., PolyGram Filmed Entertainment, 1995.

Mars Attacks! © Tim Burton, Len Brown, Woody Gelman, Wally Wood, Bob Powell, Norman Saunders, Jonathan Gems, Tim Burton Productions, Warner Bros., 1996.

Corpse Bride © Tim Burton, Mike Johnson, Carlos Grangel, John August, Caroline Thompson, Pamela Pettler, Warner Bros., Tim Burton Animation Co., Laika Entertainment, Patalex Productions, Tim Burton Productions, Will Vinton Studios, 1995.

Sleepy Hollow © Tim Burton, Washington Irving, Kevin Yagher, Andrew Kevin Walker, Paramount Pictures, Mandalay Pictures, American Zoetrope, Dieter Geissler Filmproduktion, Karol Film Productions, Tim Burton Productions, 1999.

Planet of the Apes © Tim Burton, Pierre Boulle, William Broyles Jr., Lawrence Konner, Mark Rosenthal, Twentieth Century Fox Film Corporation, The Zanuck Company, Tim Burton Productions, 2001.

Big Fish © Tim Burton, Daniel Wallace, John August, Columbia Pictures Corporation, Jinks/Cohen Company, The Zanuck Company, Tim Burton Productions, 2003.

Charlie and the Chocolate Factory © Tim Burton, Roald Dahl, John August, Warner Bros., Village Roadshow Pictures, The Zanuck Company, Plan B Entertainment, Theobald Film Productions, Tim Burton Productions, 2005.

Alice in Wonderland © Tim Burton, Linda Woolverton, Lewis Carroll, Walt Disney Pictures, Roth Films, Team Todd, The Zanuck Company, Tim Burton Productions, 2010.

Frankenweenie © Tim Burton, Leonard Ripps, John August, Walt Disney Pictures, Tim Burton Productions, 2012.

Big Eyes © Tim Burton, Scott Alexander, Larry Karaszewski, The Weinstein Company, Silverwood Films, Tim Burton Productions, Electric City Entertainment, 2014.

Pages 10–11

Paths of Glory © Stanley Kubrick, Calder Willingham, Jim Thompson, Humphrey Cob, Bryna Productions, 1957.

Spartacus © Stanley Kubrick, Dalton Trumbo, Howard Fast, Peter Ustinov, Calder Willingham, Bryna Productions, 1960.

Lolita © Stanley Kubrick, Vladimir Nabokov, Metro-Goldwyn-Mayer, Seven Arts Productions, AA Productions Ltd., Anya, Harris–Kubrick Productions, Transworld Pictures, 1962.

Dr. Strangelove or: How I Learned to Stop Worrying and Love the Bomb © Stanley Kubrick, Terry Southern, Peter George, Columbia Pictures Corporation, Hawk Films, 1964.

2001: A Space Odyssey © Stanley Kubrick, Arthur C. Clarke, Metro-Goldwyn-Mayer, Stanley Kubrick Productions, 1968.

A Clockwork Orange © Stanley Kubrick, Anthony Burgess, Warner Bros., Hawk Films, 1971.

Barry Lyndon © Stanley Kubrick, William Makepeace Thackeray, Peregrine, Hawk Films, Warner Bros., 1975.

The Shining © Stanley Kubrick, Diane Johnson, Stephen King, Warner Bros., Hawk Films, Peregrine, Producers Circle, 1980.

Full Metal Jacket © Stanley Kubrick, Gustav Hasford, Michael Herr, Natant, Stanley Kubrick Productions, Warner Bros., 1987.

Eyes Wide Shut © Stanley Kubrick, Frederic Raphael, Arthur Schnitzler, Warner Bros., Stanley Kubrick Productions, Hobby Films, Pole Star, 1999.

Pages 14–15

Rushmore © Wes Anderson, Owen Wilson, American Empirical Pictures, Touchstone Pictures, 1998.

The Royal Tenenbaums © Wes Anderson, Owen Wilson, Touchstone Pictures, American Empirical Pictures, 2001.

The Life Aquatic with Steve Zissou © Wes Anderson, Noah Baumbach, Touchstone Pictures, American Empirical Pictures, Scott Rudin Productions, Life Aquatic Productions Inc., 2004.

The Darjeeling Limited © Wes Anderson, Roman Coppola, Jason Schwartzman, Fox Searchlight Pictures, Collage Cinemagraphique, American Empirical Pictures, Dune Entertainment, Cine Mosaic, Indian Paintbrush, Scott Rudin Productions, 2007.

Fantastic Mr. Fox © Wes Anderson, Roald Dahl, Noah Baumbach, Twentieth Century Fox Film Corporation, Indian Paintbrush, Regency Enterprises, American Empirical Pictures, Twentieth Century Fox Animation, 2009.

Moonrise Kingdom © Wes Anderson, Roman Coppola, Indian Paintbrush, American Empirical Pictures, Moonrise, Scott Rudin Productions, 2012.

The Grand Budapest Hotel © Wes Anderson, Hugo Guinness, Stefan Zweig, Scott Rudin Productions, Indian Paintbrush, Studio Babelsberg, American Empirical Pictures, TSG Entertainment, 2014.

Pages 18–19

Around the World © Daft Punk, Michel Gondry, 1997.

Human Nature © Michel Gondry, Charlie Kaufman, Fine Line Features, StudioCanal, Good Machine, Beverly Detroit, Partizan Films, Senator Film Produktion, 2001.

Eternal Sunshine of the Spotless Mind © Michel Gondry, Charlie Kaufman, Pierre Bismuth, Focus Features, Anonymous Content, This Is That Productions, 2004.

The Science of Sleep © Michel Gondry, Partizan Films, Gaumont, France 3 cinéma, Canal+, TPS Star, Mikado Film, 2006.

Be Kind Rewind © Michel Gondry, New Line Cinema, Partizan Films, Focus Features, 2008.

The Green Hornet © Michel Gondry, Seth Rogen, Evan Goldberg, George W. Trendle, Columbia Pictures, Original Film, K/O Camera Toys, 2011.

The We and the I © Michel Gondry, Jeffrey Grimshaw, Paul Proch, Partizan Films, Jouror Productions, Next Stop Production, 2012.

Mood Indigo © Michel Gondry, Luc Bossi, Boris Vian, Brio films, StudioCanal, Scope Pictures, France 2 Cinéma, Hérodiade, Radio-Télévision Belge Francophone, Belgacom, 2013.

Is the Man Who Is Tall Happy?: An Animated Conversation with Noam Chomsky © Michel Gondry, Partizan Films, 2013.

Microbe and Gasoline © Michel Gondry, Partizan Films, StudioCanal, Canal+, Orange Cinéma Séries, Indéfilms 3, Cinémage 9, Région Bretagne, Centre National de la Cinématographie, Commission du Film de Bourgogne, 2015.

Pages 22–23

Rebecca © Alfred Hitchcock, Daphne Du Maurier, Robert E. Sherwood, Joan Harrison, Philip MacDonald, Michael Hogan, Selznick International Pictures, 1940.

Lifeboat © Alfred Hitchcock, John Steinbeck, Jo Swerling, Ben Hecht, Twentieth Century Fox Film Corporation, 1944.

Dial M for Murder © Alfred Hitchcock, Frederick Knott, Warner Bros., 1954.

Rear Window © Alfred Hitchcock, John Michael Hayes, Cornell Woolrich, Paramount Pictures, Patron Inc., 1954.

Vertigo © Alfred Hitchcock, Alec Coppel, Samuel A. Taylor, Pierre Boileau, Thomas Narcejac, Maxwell Anderson, Alfred J. Hitchcock Productions, 1958.

North by Northwest © Alfred Hitchcock, Ernest Lehman, Metro-Goldwyn-Mayer, 1959.

Psycho © Alfred Hitchcock, Joseph Stefano, Robert Bloch, Shamley Productions, 1960.

The Alfred Hitchcock Hour © Alf Kjellin, Joseph M. Newman, Bernard Girard, James Bridges, Henry Slesar, Arthur A. Ross, Shamley Productions, 1962–1965.

The Birds © Alfred Hitchcock, Daphne Du Maurier, Evan Hunter, Alfred J. Hitchcock Productions, 1963.

Marnie © Alfred Hitchcock, Winston Graham, Jay Presson Allen, Alfred J. Hitchcock Productions, 1964.

Pages 26–27

Duel © Steven Spielberg, Richard Matheson, Universal Television, 1971.

Jaws © Steven Spielberg, Peter Benchley, Carl Gottlieb, Zanuck/Brown Productions, Universal Pictures, 1975.

Close Encounters of the Third Kind © Steven Spielberg, Hal Barwood, Jerry Belson, John Hill, Matthew Robbins, Columbia Pictures Corporation, EMI Films, Julia Phillips and Michael Phillips Productions, 1977.

Raiders of the Lost Ark © Steven Spielberg, Lawrence Kasdan, George Lucas, Philip Kaufman, Paramount Pictures, Lucasfilm, 1981.

E.T. the Extra-Terrestrial © Steven Spielberg, Melissa Mathison, Universal Pictures, Amblin Entertainment, 1982.

Indiana Jones and the Temple of Doom © Steven Spielberg, Willard Huyck, Gloria Katz, George Lucas, Paramount Pictures, Lucasfilm, 1984.

Gremlins © Joe Dante, Chris Columbus, Warner Bros., Amblin Entertainment, 1984.

Back to the Future © Robert Zemeckis, Bob Gale, Universal Pictures, Amblin Entertainment, U-Drive Productions, 1985.

Indiana Jones and the Last Crusade © Steven Spielberg, Jeffrey Boam, George Lucas, Menno Meyjes, Philip Kaufman, Paramount Pictures, Lucasfilm, 1989.

Hook © Steven Spielberg, J. M. Barrie, James V. Hart, Nick Castle, Malia Scotch Marmo, Amblin Entertainment, TriStar Pictures, 1991.

Jurassic Park © Steven Spielberg, Michael Crichton, David Koepp, Universal Pictures, Amblin Entertainment, 1993.

Schindler's List © Steven Spielberg, Thomas Keneally, Steven Zaillian, Universal Pictures, Amblin Entertainment, 1993.

Amistad © Steven Spielberg, David Franzoni, DreamWorks SKG, Home Box Office, 1997.

Saving Private Ryan © Steven Spielberg, Robert Rodat, DreamWorks SKG, Paramount Pictures, Amblin Entertainment, Mutual Film Company, Mark Gordon Productions, 1998.

Artificial Intelligence: A.I. © Steven Spielberg, Brian Aldiss, Ian Watson, Warner Bros., DreamWorks SKG, Amblin Entertainment, Stanley Kubrick Productions, 2001.

Catch Me if You Can © Steven Spielberg, Jeff Nathanson, Frank Abagnale Jr., Stan Redding, DreamWorks SKG, Kemp Company, Splendid Pictures, Parkes+MacDonald Image Nation, Amblin Entertainment, Muse Entertainment Enterprises, 2002.

Minority Report © Steven Spielberg, Philip K. Dick, Scott Frank, Jon Cohen, Twentieth Century Fox Film Corporation, DreamWorks SKG, Cruise/Wagner Productions, Blue Tulip Productions, Ronald Shusett/Gary Goldman, Amblin Entertainment, Digital Image Associates, 2002.

War of the Worlds © Steven Spielberg, Josh Friedman, David Koepp, H. G. Wells, Paramount Pictures, DreamWorks SKG, Amblin Entertainment, Cruise/Wagner Productions, 2005.

Indiana Jones and the Kingdom of the Crystal Skull © Steven Spielberg, David Koepp, George Lucas, Jeff Nathanson, Philip Kaufman, Paramount Pictures, Lucasfilm, 2008.

The Adventures of Tintin © Steven Spielberg, Steven Moffat, Edgar Wright, Joe Cornish, Hergé, Columbia Pictures, Paramount Pictures, Amblin Entertainment, WingNut Films, The Kennedy/Marshall Company, Hemisphere Media Capital, Nickelodeon Movies, 2011.

Lincoln © Steven Spielberg, Tony Kushner, Doris Kearns Goodwin, DreamWorks SKG, Twentieth Century Fox Film Corporation, Reliance Entertainment, Participant Media, Dune Entertainment, Amblin Entertainment, The Kennedy/Marshall Company, Walt Disney Studios Motion Pictures, 2012.

Bridge of Spies © Steven Spielberg, Matt Charman, Ethan Coen, Joel Coen, Amblin Entertainment, DreamWorks SKG, Fox 2000 Pictures, Marc Platt Productions, Participant Media, Reliance Entertainment, Studio Babelsberg, TSG Entertainment, 2015.

Pages 30–31

Women on the Verge of a Nervous Breakdown (Mujeres al borde de un ataque de nervios) © Pedro Almodóvar, Jean Cocteau, El Deseo, Laurenfilm, 1988.

High Heels (Tacones lejanos) © Pedro Almodóvar, Canal+, Ciby 2000, El Deseo, TF1 films production, 1991.

Kika © Pedro Almodóvar, El Deseo, Ciby 2000, 1993.

All About My Mother (Todo sobre mi madre) © Pedro Almodóvar, El Deseo, Renn productions, France 2 cinéma, Vía Digital, 1999.

Talk to Her (Hable con ella) © Pedro Almodóvar, El Deseo, Antena 3 Televisión, Good Machine, Vía Digital, 2002.

Bad Education (La mala educación) © Pedro Almodóvar, Canal+ España, El Deseo, Televisión Española, 2004.

Volver © Pedro Almodóvar, Canal+ España, El Deseo, Ministerio de Cultura, Televisión Española, 2006.

Broken Embrace (Los abrazos rotos) © Pedro Almodóvar, Universal Pictures International, Canal+ España, El Deseo, Instituto de Crédito Oficial, Instituto de la Cinematografía y de las Artes Audiovisuales, Lanzarote Reserva de Biosfera, Ministerio de Cultura, Televisión Española, 2009.

The Skin I Live In (La piel que habito) © Pedro Almodóvar, Agustín Almodóvar, Thierry Jonquet, Blue Haze Entertainment, Canal+ España, El Deseo, FilmNation Entertainment, Instituto de Crédito Oficial, Instituto de la Cinematografía y de las Artes Audiovisuales, Televisión Española, 2011.

I'm So Excited (Los amantes pasajeros) © Pedro Almodóvar, El Deseo, 2013.

Pages 34–35

Blood Simple © Joel Coen, Ethan Coen, River Road Productions, Foxton Entertainment, 1984.

Raising Arizona © Joel Coen, Ethan Coen, Circle Films, 1987.

Miller's Crossing © Joel Coen, Ethan Coen, Dashiell Hammett, Circle Films, Twentieth Century Fox Film Corporation, 1990.

Barton Fink © Joel Coen, Ethan Coen, Circle Films, Working Title Films, 1991.

Fargo © Joel Coen, Ethan Coen, PolyGram Filmed Entertainment, Working Title Films, 1996.

The Big Lebowski © Joel Coen, Ethan Coen, PolyGram Filmed Entertainment, Working Title Films, 1998.

O Brother, Where Art Thou? © Joel Coen, Ethan Coen, Homer, Touchstone Pictures, Universal Pictures, StudioCanal, Working Title Films, Mike Zoss Productions, Buena Vista Pictures, 2000.

The Man Who Wasn't There © Joel Coen, Ethan Coen, Good Machine, Gramercy Pictures, Mike Zoss Productions, The KL Line, Working Title Films, 2001.

Ladykillers © Joel Coen, Ethan Coen, William Rose, Touchstone Pictures, The Jacobson Company, Mike Zoss Productions, Pancake Productions Inc., 2004.

No Country for Old Men © Joel Coen, Ethan Coen, Cormac McCarthy, Paramount Vantage, Miramax, Scott Rudin Productions, Mike Zoss Productions, 2007.

Burn after Reading © Joel Coen, Ethan Coen, Focus Features, StudioCanal, Relativity Media, Working Title Films, Mike Zoss Productions, 2008.

A Serious Man © Joel Coen, Ethan Coen, Focus Features, StudioCanal, Relativity Media, Mike Zoss Productions, Working Title Films, 2009.

True Grit © Joel Coen, Ethan Coen, Charles Portis, Paramount Pictures, Skydance Productions, Scott Rudin Productions, Mike Zoss Productions, 2010.

Inside Llewyn Davis © Joel Coen, Ethan Coen, CBS Films, StudioCanal, Anton Capital Entertainment, Mike Zoss Productions, Scott Rudin Productions, 2013.

Hail, Caesar! © Joel Coen, Ethan Coen, Dentsu, Mike Zoss Productions, Working Title Films, 2016.

Pages 38–39

Eraserhead © David Lynch, American Film Institute, Libra Films, 1977.

Elephant Man © David Lynch, Christopher De Vore, Eric Bergren, Frederick Treves, Ashley Montagu, Brooksfilms, 1980.

Dune © David Lynch, Frank Herbert, Dino De Laurentiis Company, 1984.

Blue Velvet © David Lynch, De Laurentiis Entertainment Group, 1986.

Wild at Heart © David Lynch, Barry Gifford, PolyGram Filmed Entertainment, Propaganda Films, 1990.

Twin Peaks © David Lynch, Mark Frost, Lynch/Frost Productions, Propaganda Films, Spelling Entertainment Twin Peaks Productions, 1990-1991.

Twin Peaks: Fire Walk with Me © David Lynch, Robert Engels, Mark Frost, New Line Cinema, Ciby 2000, Twin Peaks Productions, 1992.

Lost Highway © David Lynch, Barry Gifford, October Films, Ciby 2000, Asymmetrical Productions, Lost Highway Productions LLC, 1997.

The Straight Story © David Lynch, John Roach, Mary Sweeney, Asymmetrical Productions, Canal+, Channel Four Films, Ciby 2000, Les Films Alain Sarde, StudioCanal, The Picture Factory, The Straight Story Inc., Walt Disney Pictures, 1999.

Mulholland Dr. © David Lynch, Les Films Alain Sarde, Asymmetrical Productions, Babbo Inc., Canal+, The Picture Factory, 2001.

Inland Empire © David Lynch, StudioCanal, Fundacja Kultury, Camerimage Festival, Absurda, Asymmetrical Productions, Inland Empire Productions, 2006.

Pages 42–43

Taxi Driver © Martin Scorsese, Paul Schrader, Columbia Pictures Corporation, Bill/Phillips, Italo/Judeo Productions, 1976.

Raging Bull © Martin Scorsese, Jake LaMotta, Joseph Carter, Peter Savage, Paul Schrader, Mardik Martin, United Artists, Chartoff-Winkler Productions, 1980.

After Hours © Martin Scorsese, Joseph Minion, The Geffen Company, Double Play, 1985.

The Color of Money © Martin Scorsese, Walter Tevis, Richard Price, Touchstone Pictures, Silver Screen Partners II, 1986.

The Last Temptation of Christ © Martin Scorsese, Nikos Kazantzakis, Paul Schrader, Universal Pictures, Cineplex Odeon Films, 1988.

Goodfellas © Martin Scorsese, Nicholas Pileggi, Warner Bros., 1990.

Casino © Martin Scorsese, Nicholas Pileggi, Universal Pictures, Syalis DA, Légende entreprises, De Fina-Cappa, 1995.

Bringing Out the Dead © Martin Scorsese, Joe Connelly, Paul Schrader, De Fina-Cappa, Paramount Pictures, Touchstone Pictures, 1999.

Gangs of New York © Martin Scorsese, Jay Cocks, Steven Zaillian, Kenneth Lonergan, Miramax, Initial Entertainment Group, Alberto Grimaldi Productions, 2002.

The Aviator © Martin Scorsese, John Logan, Forward Pass, Appian Way, IMF Internationale Medien und Film GmbH & Co. 3. Produktions KG, Initial Entertainment Group, Warner Bros., Miramax, Cappa Productions, Mel's Cite du Cinema, 2004.

The Departed © Martin Scorsese, William Monahan, Alan Mak, Felix Chong, Warner Bros., Plan B Entertainment, Initial Entertainment Group, Vertigo Entertainment, Media Asia Films, 2006.

Shutter Island © Martin Scorsese, Laeta Kalogridis, Dennis Lehane, Paramount Pictures, Phoenix Pictures, Sikelia Productions, Appian Way, 2010.

Hugo © Martin Scorsese, John Logan, Brian Selznick, Paramount Pictures, GK Films, Infinitum Nihil, 2011.

The Wolf of Wall Street © Martin Scorsese, Terence Winter, Jordan Belfort, Paramount Pictures, Red Granite Pictures, Appian Way, Sikelia Productions, EMJAG Productions, 2013.

Pages 46–47

Reservoir Dogs © Quentin Tarantino, Roger Avary, Live Entertainment, Dog Eat Dog Productions Inc., 1992.

Pulp Fiction © Quentin Tarantino, Roger Avary, Miramax Films, A Band Apart, Jersey Films, 1994.

Jackie Brown © Quentin Tarantino, Elmore Leonard, Miramax, A Band Apart, Lawrence Bender Productions, Mighty Mighty Afrodite Productions, 1997.

Kill Bill: Vol. 1 © Quentin Tarantino, Miramax Films, A Band Apart, Supercool Manchu, 2003.

Kill Bill: Vol. 2 © Quentin Tarantino, Uma Thurman, Miramax, A Band Apart, Super Cool Manchu, 2004.

Death Proof © Quentin Tarantino, Dimension Films, Troublemaker Studios, Rodriguez International Pictures, The Weinstein Company, 2007.

Inglourious Basterds © Quentin Tarantino, Eli Roth, Universal Pictures, The Weinstein Company, A Band Apart, Studio Babelsberg, Visiona Romantica, 2009.

Django Unchained © Quentin Tarantino, The Weinstein Company, Columbia Pictures, 2012.

The Hateful Eight © Quentin Tarantino, Double Feature Films, FilmColony, 2015.

The editor thanks
Minh Fâ and Caroline
Merceron for their
invaluable collaboration.

First published in the United
States in 2017 by Chronicle Books
LLC. First published in France in
2016 by Milan et demi, a division of
Editions Milan. Copyright © 2016, 2017 by
Milan et demi. All Rights Reserved. No part
of this book may be reproduced in any form
without written permission from the publisher.

ISBN: 978-1-4521-6630-8
Manufactured in China

10 9 8 7 6 5 4 3 2 1
Chronicle Books LLC
680 Second Street
San Francisco, California 94107
www.chroniclebooks.com

Chronicle books and gifts are available at special quantity discounts to
corporations, professional associations, literacy programs, and other organizations.
For details and discount information, please contact our premiums department
at corporatesales@chroniclebooks.com or at 1-800-759-0190.